JEAN-MICHEL BASQUIAT

HANDBOOK

edited by
LARRY WARSH

NO MORE RULERS

In association with No More Rulers
nomorerulers.com @nomorerulers

NO MORE RULERS ®

The NO MORE RULERS mark and logo are
registered trademarks of No More Rulers, Inc.

ISBN: 979-8-9889286-0-7

Design by Hannah Alderfer, HHAdesign

This book has been composed in Helvetica Neue Pro

Printed on acid-free paper

Printed in China

CONTENTS

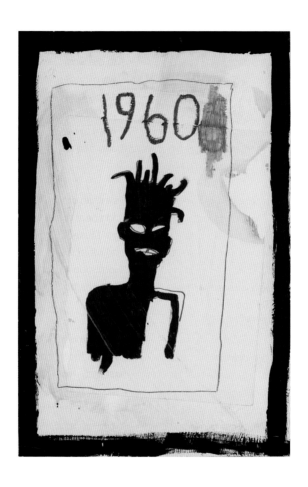

Untitled (1960), 1983, acrylic and oilstick on paper,
36 x 24 inches (91.4 x 61 cm)

FOREWORD

This handbook is an introduction to the world of Jean-Michel Basquiat (1960–1988)—a way of understanding and getting to know the artist and his work, where he came from, his family and his roots. Decades after his untimely death, Jean-Michel remains a towering figure in contemporary art, and a role model and influence to so many around the globe.

In crucial ways, Jean-Michel was a child of New York City. He played in city streets and spent time in city museums—notably the Brooklyn Museum, where he was enrolled in art classes and often visited with his family. His childhood neighborhoods were lively with street life, especially the brownstone stoops of Brooklyn.

Jean-Michel soaked up the city and gave it back in the creative exuberance of his vision. Incorporating words, text, and language mashups, his art can have a spontaneous, improvisational feeling. From paintings to found objects to notebook pages, the breadth and depth of his oeuvre is astounding, especially given the brief span of his career. The work is threaded with ideas, themes, and visual motifs that appear again and again, and in this handbook we spotlight those common elements, exploring them one by one. Reminiscences by family and friends add an unexpectedly personal dimension.

It speaks to the energy and the integrity of Basquiat's art that it can still influence so many and generate the strong connections and reactions that it does. Instinctual and streetwise, his work also reflects an acute grasp of art history, world history, and current events. It incorporates a range of artistic traditions— Impressionism, Fauvism, and Expressionism, among others—while referencing everything from ancient Egyptian, African, and Aztec cultures to 20th-century Black athletes and musicians.

Very few artists embodied and translated freedom to the canvas like Jean-Michel. And while the 1980s New York art scene that he thrived in is long gone, we can be grateful that his work gives us a breath of that exuberance, filtered through his own unique sensibility. He has influenced generations and will inspire many more to come.

My goal in creating this handbook is to offer a guide to Jean-Michel's world, both for new audiences and for those looking to deepen their understanding of his work. It is a primer and an introduction to his art, but it is also an invitation: to enter his world, to become absorbed by his creative processes, and to perhaps inspire your own.

Larry Warsh
New York City
September 2023

"I think I make art for myself, but ultimately I think I make it for the world."*

*Dunlop, Geoff, and Sandy Nairne. "Andy Warhol and Jean-Michel Basquiat." Channel 4 with WDR Koln, 11 January–15 February 1987, State of the Art, episode 6.

Jean-Michel Basquiat, 1962

EARLY YEARS & FAMILY LIFE

Jean-Michel Basquiat's journey as a celebrated artist began during his youth, and his early years and family life were a significant aspect of his creative development. Jean-Michel was born on December 22, 1960, the first of three surviving children born to his father Gerard Basquiat and his mother Mathilde Andrades. His younger sisters Lisane (b.1964) and Jeanine (b.1967) were born several years later. His loving family and lively home environment were bolstered by a large extended family that included grandparents, uncles, cousins, and close family friends.

Jean-Michel's family is representative of many who come to the United States to seek personal success through determination and hard work. His father Gerard emigrated from Haiti to New York in 1955 and began employment in the Garment District of Manhattan before going on to work for MacMillan Films. His mother Mathilde's family left Puerto Rico to establish themselves in Bushwick, Brooklyn. Sharing a passion for music, Gerard and Mathilde first met at a dance hall in Brooklyn and married in 1957. Gerard later attended City College while working full-time and Mathilde raised their children. The Basquiat family made a point of having dinner together every evening, and cooking and meals were a cherished cornerstone of their life together.

Growing up in the diverse culture of Brooklyn during the 1960s and '70s was a cheerful time for Jean-Michel. He and his sisters thrived in the various Brooklyn neighborhoods where they lived: Prospect Heights, Boerum Hill, and East Flatbush. As a child Jean-Michel was surrounded by a caring family, great food, music, art, and the urban architecture of his native city. He and his sisters often enjoyed the local cultural offerings, including regular visits to the Brooklyn Museum, the Botanic Garden, and Prospect Park Zoo, plus family outings to Rockaway Beach in Queens, NY, during the summer. As children they often spent playful hours in the spacious meadows of Prospect Park near Flatbush Avenue.

Although Gerard and Mathilde separated when Jean-Michel was only 8 years old, the family remained extremely close. Jean-Michel and his sisters lived with Gerard during the years that followed but they spent every Saturday with their mother. Mathilde would take the children to see plays, museums, and movies, and on the occasional roller-skating outing. During the mid-1970s, Jean-Michel and his family relocated to San Juan, Puerto Rico, and Gerard was a reliable single father for his three kids. The camaraderie among the siblings was strong, and their shared sense of curiosity and adventure afforded them solace when they missed their mother in New York. During their time in Puerto Rico the young

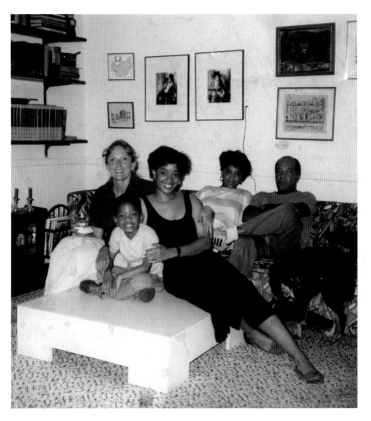

Nora Fitzpatrick, Lisane's son Joseph, Lisane, Jeanine, Gerard,
and their dog Ginger, Boerum Hill, Brooklyn, 1986

JEAN MICHEL BASQUIAT BORN DEC. 22/1960/BROOKLYN/N.Y.)

MOTHER: PUERTO RICAN (FIRST GENERATION)
FATHER: IN PORT·AU·PRINCE, HAITI.
(DIVORCED)

ST. ANNS
?
P.S. 6
P.S. 101
P.S. 45
I.S. 293
CITY AS SCHOOL

[NAME OF THE. TOWN]

(SOME CATHOLIC SCHOOL
DURING YEAR + ½ IN
PUERTO RICO

11 TH GRADE DROPOUT

① PUT A BOX OF SHAVING
CREAM IN PRINCIPAL'S
FACE AT GRADUATION

FIRST AMBITION: FIREMAN

FIRST ARTISTIC AMBITION: CARTOONIST.

NO POINT
IN GOING
BACK

EARLY THEMES WERE THE:

①. THE SEAVIEW FROM "VOYAGE TO THE BOTTOM OF THE SEA"
2. ALFRED. E. NEUMAN
3. ALFRED HITCHCOCK (HIS FACE OVER + OVER)
4. NIXON
5. CARS (MOSTLY DRAGSTER)S.
6. WARS ⑧ MADE DRAWINGS OF OOPICK + FRITZ + HAIR + YABOO
7. WEAPONS. WITH MARC PROZZO.

Ⓐ. SENT A DRAWING OF A GUN TO J. EDGAR HOOVER IN 3ʳᵈ Grd.
(NO REPLY) THIRD GRADE

TAUGHT SECOND GRADERS WHEN I WAS IN
THE FOURTH GRADE. (CARS MADE OF PAPERCLIPS
 (MASKING TAPE +
 FASTENERS.

SCHOOLING: SOME LIFE DRAWING IN NINTH GRADE.
 ACADEMIC (WAS THE ONLY CHILD THAT FAILED)

EARLY MUSIC INFLUENCES: WEST SIDE STORY
 THE "WATUSI"
 ROUND 'BOUT MIDNIGHT
 WALKING HAPPY
 BLACK ORPHEUS.

Untitled (Biography), 1983, mixed media on paper
8 x 12 inches (20.3 x 30.5 cm)
© Estate of Jean-Michel Basquiat. Licensed by Artestar, New York

Jean-Michel, Jeanine, and Lisane often rode their bikes to the beach and reveled in the clear waters of the Caribbean Sea. These were jubilant times that also expanded Jean-Michel's understanding of place, community, and culture.

After two years, Gerard and his children returned to the Boerum Hill section of Brooklyn and moved into a townhouse that their father had purchased years earlier. Jean-Michel and his sisters were happy to rekindle their life on the East Coast, which included the charms of changing seasons. There was a tight-knit community in their neighborhood and the families looked out for each other. Jean-Michel and his sisters socialized with many kids their age and appreciated the many walks of life they encountered and engaged with on the stoops of the classic brownstone buildings in their neighborhood. There was always a flow of communal energy and impromptu block parties most weekends.

As the Basquiat family grew up together, expression and ingenuity were fundamental to the creative ethos of their household, and a range of music was especially prevalent. From an early time of life Jean-Michel and his sisters were exposed to jazz, merengue, classical, and disco, among other musical genres. There was always some form of melody playing in their home and this would prove to be a significant influence on Jean-Michel and his creative process.

In 1977, Gerard began a lifelong relationship with Nora Fitzpatrick, and they remained together until Gerard's death in July 2013. As the years rolled on, Gerard, Nora, and the Basquiat children regularly welcomed guests for festive evenings, and everyone took part in the entertaining and conviviality. Jean-Michel and his sisters grew up in the midst of these boisterous times, and Gerard encouraged their imagination by announcing to the invited company that there would be live performances as part of the activities. Jean-Michel's sisters would put together dance routines, songs, and comedy skits for these parties. The children experienced a buoyant upbringing together in a home that was constantly filled with music, singing, dancing, and merriment among family and friends.

By the time Jean-Michel reached high school as a student at City-as-School, he was a skilled draftsman who excelled at drawing and doing illustrations for the school newspaper. During his teenage years he was regularly drawing, scribbling, creating, and devising plans for new projects. It became clear that Jean-Michel's intelligence, talents, and singular genius held great potential. His amiable family life and fun-loving early years with his sisters had provided a confident foundation that launched Jean-Michel into the next phase of his outstanding artistic life.

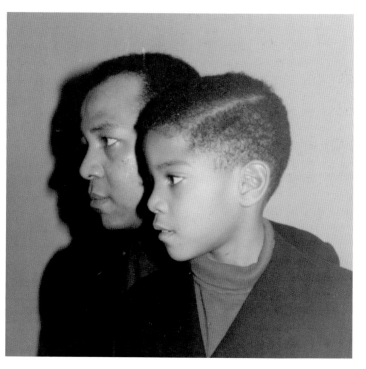

Gerard and Jean-Michel, 1968

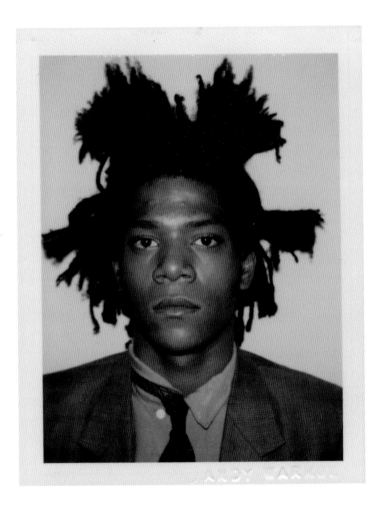

Andy Warhol, *Jean-Michel Basquiat*, 1982
The Andy Warhol Museum, Pittsburgh; Contribution
The Andy Warhol Foundation for the Visual Arts, Inc. 2000.2.813

WHO IS JEAN-MICHEL BASQUIAT?

Jean-Michel Basquiat is one of the most successful Black visual artists in history, though his career was very brief and it ended abruptly and tragically. He emerged on the New York City arts scene in the late 1970s and quickly skyrocketed to international fame, becoming one of the most important artists of his generation.

During his short life, Basquiat created artwork across several disciplines, including graffiti, painting, sculpture, and drawing. He is one of a small number of African-American-Latinx artists to be recognized internationally. Yet his rapid rise to success spurred controversy, as well as a great deal of speculation and misunderstanding about his work, his personal life, and the New York art world.

Basquiat was born in 1960 to a middle-class family in Brooklyn. His father was Haitian and his mother was of Puerto Rican descent. Basquiat developed an interest in art at an early age, and as a kid, he loved to draw. He found inspiration in pop culture, including cartoons, Alfred Hitchcock's films, and jazz music by Miles Davis and Charlie Parker. To encourage his interest in art, his mother bought him a copy of the classic textbook *Gray's Anatomy* and often took him to museums, including the Brooklyn Museum, the Metropolitan Museum of Art, and the Museum of Modern Art.

As a teenager, Basquiat became less interested in school and more active in art making. He began his career spray-painting words and images on buildings throughout the city during the late 1970s, a time when several graffiti artists—including Keith Haring and Fred Brathwaite—used chalk, crayon, and spray paint to draw and write on public property as a way of critiquing and commenting on urban life.

Basquiat collaborated on spray-painted street writings with his friend Al Diaz under the tag name SAMO©, which stood for "Same Old Shit." After an influential weekly newspaper, the *Village Voice*, published an article about the two teens in 1978, Basquiat quickly became a well-known artist in the downtown scene.

Unfortunately, the fruitful collaboration ended—along with his friendship with Diaz—shortly after, though Basquiat continued to include the name SAMO© in his artworks. Around the same time, Basquiat left home, dropped out of high school, and began selling postcards and T-shirts featuring his artwork.

He continued to visit museums frequently and began teaching himself how to paint based on what he saw in galleries and art books. He became quite knowledgeable about the history of art and used what he learned in his own practice. Living artists

were also important to him, especially Andy Warhol, who later became a close friend and collaborator.

At a party, Basquiat befriended Fred Brathwaite, a musician and graffiti artist also known as Fab 5 Freddie. Brathwaite connected Basquiat to hip-hop culture, and together they made the transition from graffiti to painting on canvas to gallery exhibitions. Basquiat's paintings quickly drew the attention of art critics and dealers.

Basquiat had his own style, which combined elements of the African diaspora with his own unique symbolism. His art incorporated wordplay as well as themes of urban life, social and racial inequalities, popular culture, and world history.

A variety of techniques are on display in Basquiat's work, including scribbling, collage, painting, and drawing, and he filled his surfaces with images, words, textures, and texts. This exciting mix of words and images is not always easy to interpret, and the artist did not like to explain his paintings. He wanted people to look and respond to them without being told exactly what they meant.

However, the symbols, phrases, lists, poems, and individual words in his works can help us understand his intentions as an artist. They can give us insights into how he felt about his identity, about being an

artist, and about how he made sense of the world around him.

Basquiat's career as an artist was brief but extremely successful. The critical reception of his paintings was strong and positive, and the market for them was enthusiastic. Yet tragically, in 1988, before reaching his twenty-eighth birthday, he died of a drug overdose.

In his ten-year career, Basquiat produced approximately 600 paintings and 1,500 drawings, a small group of sculptural works, numerous street writings, and an unknown number of notebooks. Today, Jean-Michel Basquiat's work and legacy continue to influence popular culture, especially art, music, and fashion.

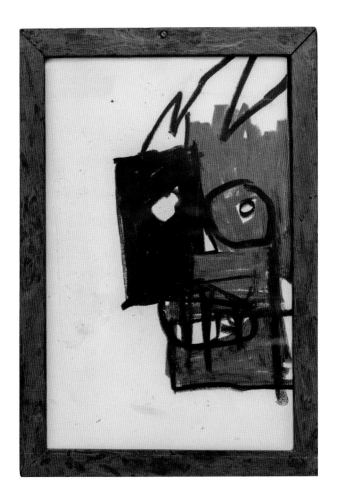

Untitled, 1982, mixed media on paper with artist frame,
7 x 5 inches (17.7 x 12.7 cm)

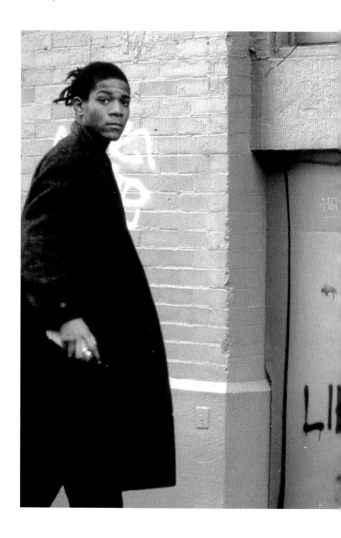

Jean-Michel Basquiat on the set of *Downtown 81*, 1980–81,
© New York Beat Films, LLC. Photo: Michael Van Horn.
Artwork: © Estate of Jean-Michel Basquiat. Licensed by Artestar, New York

Downtown 81 is a feature film starring Basquiat. The film follows him as he wanders the streets of New York City and is a rare snapshot into the subculture of Manhattan in the 1980s.

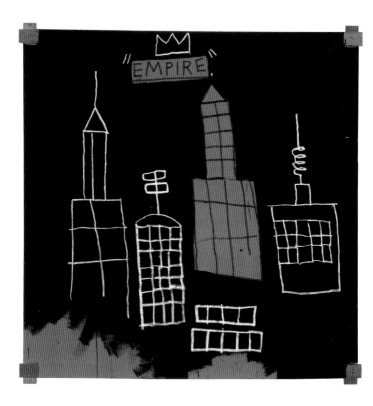

Mecca—derived from the official designation of Makkah al-Mukarrah for the seat of administrative and religious authority as the holiest city of Islam—is transported here to Manhattan and transformed into its colloquial meaning as the center for specific groups or activities, in this case conjured as a promised land of opportunity and a muse for artists.

Mecca, 1982, acrylic and oilstick on canvas,
70 x 67⁷/₈ inches (177.8 x 172.4 cm)
© Estate of Jean-Michel Basquiat. Licensed by Artestar, New York

THEMES AND TOPICS

URBAN LIFE

Basquiat filled his work with commentary and reflections on urban life. The streets of New York City and his experiences on them remain at the heart of his imagery. In his work, you will discover cars, buildings, cityscapes, police, children's sidewalk games, and graffiti, among other references to city life.

Basquiat also incorporated found objects into his works. Before he could afford to buy canvas, he painted on any available surface, such as abandoned doors, windows, and boxes. His fellow artist Fred Brathwaite said of Basquiat: "He could assimilate and digest an incredible amount of imagery, an incredible amount of information—words and pictures. He was able to take those things and synthesize them on canvas, on paper, with his own personal twist and vision that related to an entire history of contemporary art, yet that spoke directly and immediately to the times we were living in."

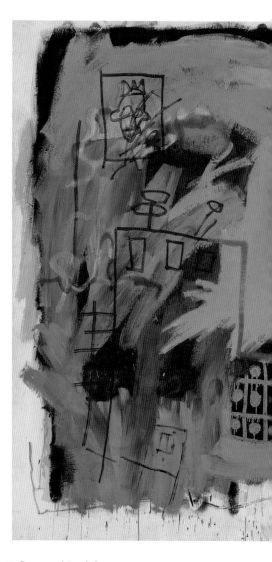

Untitled, 1981, acrylic, spray paint, and oil on canvas,
86 × 104 inches (218.4 × 264.2 cm)

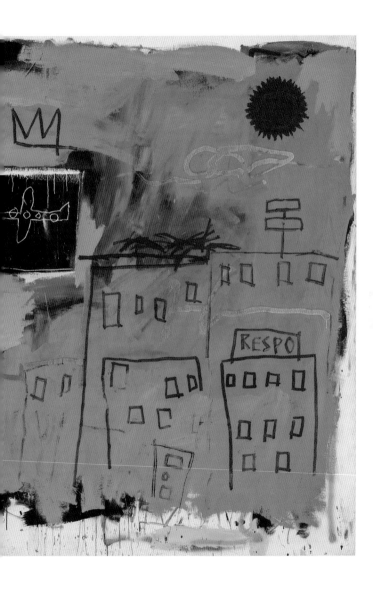

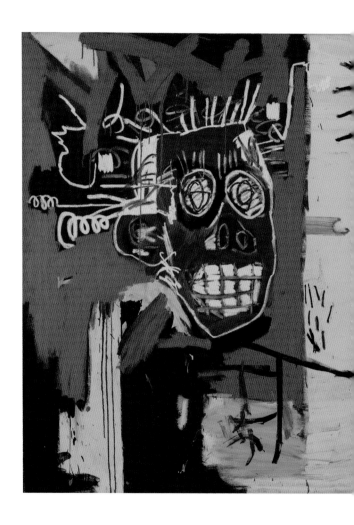

Two Heads on Gold, 1982, acrylic and crayon on canvas, 80 x 125 inches (203 x 317.5 cm)

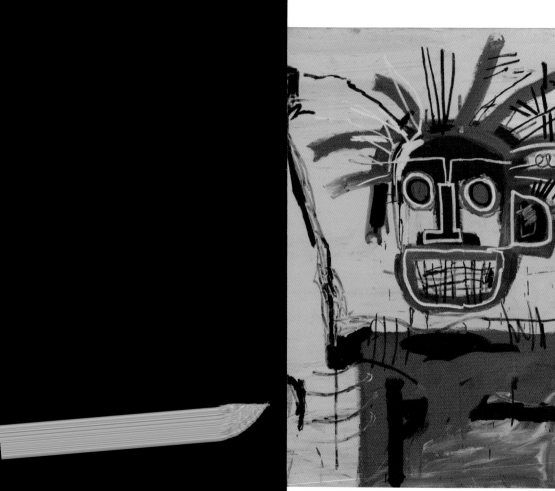

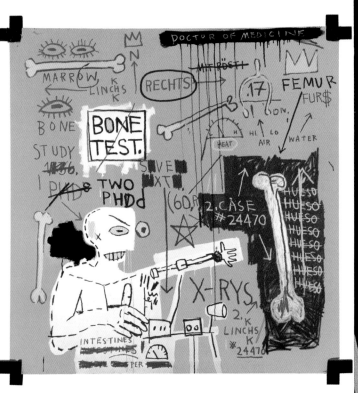

Carbon Dating System versus Scratchproof Tape, 1982, acrylic on canvas,
72 x 72 inches (182.9 x 182.9 cm)

THE HUMAN FIGURE

Basquiat had a lifelong interest in anatomy. In 1968, while recovering in the hospital after being hit by a car at the age of seven, he studied a copy of *Gray's Anatomy* that his mother had given him, poring over its detailed drawings of the human body—skin, muscle, bone, organs, and more.

Most artists' training includes the study of anatomy, and Basquiat was no exception. His interest in the human body continued as a central theme in his work. He eventually abandoned images of the city and began to depict the human figure, developing a unique style featuring skeletal figures—many of whom reveal their internal anatomies and organs. He often gave figures a halo or crown, lending them an air of royalty, superiority, dignity, and distinction.

"I don't think about art when I'm working. I try to think about life."*

*Basquiat, Jean-Michel. "Waiting for Basquiat." Interview by Isabella Graw. Wolkenkratzer Art Journal, Frankfurt, no. 1, January–February 1987.

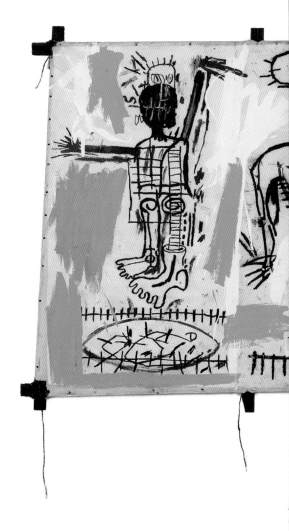

Baby Boom, 1982, acrylic and oilstick on cavas,
49 × 84 inches (124.5 × 213.4 cm)

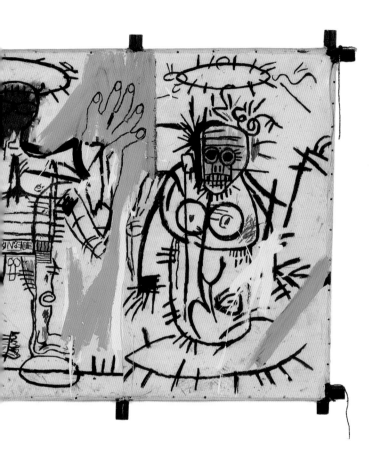

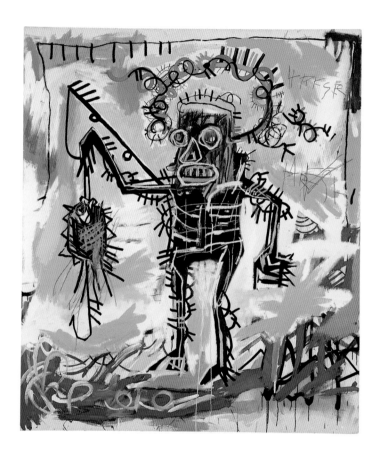

Untitled (Fishing), 1981, oilstick, acrylic and spray enamel on canvas,
78 × 68 inches (198.1 × 172.7 cm)

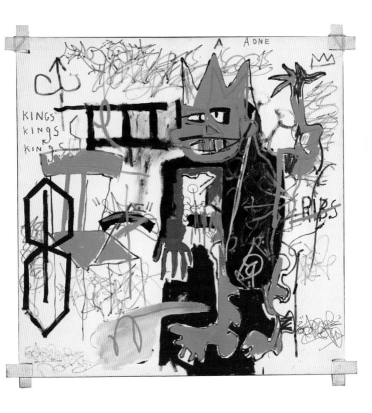

Portrait of A-One A.K.A. King, 1982, acrylic, oilstick and marker on canvas,
68 × 68 inches (172.5 × 172.5 cm)

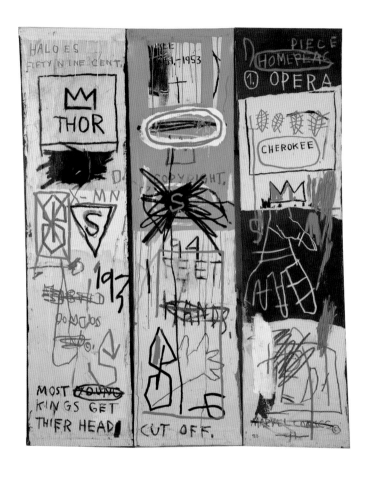

Charles the First, 1982, acrylic and oilstick on canvas, triptych,
78 x 62 inches (198 x 158 cm)

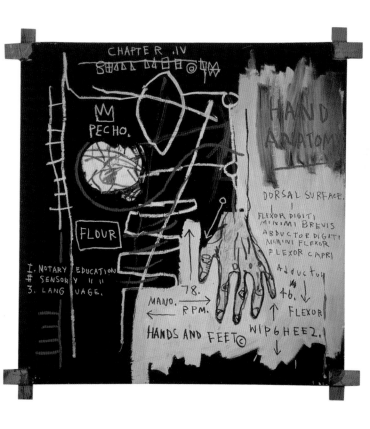

Untitled (Hand Anatomy), 1982, acrylic on canvas,
60 x 60 inches (152.4 x 152.4 cm)

WORDS AND PHRASES

Some people think Basquiat was more of a writer than a painter. All the words in Basquiat's paintings and drawings have multiple layers of reference and hold charged meanings. For Fred Brathwaite, "the writing aspect of Jean-Michel's work was like some visual type of poetry. The way he would put words on the surface and would not complete a word or would make a word differently than how we're used to seeing it. If you read his canvases out loud to yourself, the repetition, the rhythm, you can hear Jean-Michel thinking. You can see that this is a poetic, rhythmic type of blending of word with image."

In selecting words and phrases, Basquiat used a wide variety of sources. Many came from his favorite history books. Like his images and symbols, some words reappeared in several works. At times he crossed out words—a practice that became another trademark for him.

Among the topics Basquiat regularly addressed through words are money; authenticity; ownership; commodities of trade and commerce; food products and junk food; historical Black figures, such as athletes, boxers, and musicians; symbols of oppression; references to racism; and cartoons and comic book characters.

Tuxedo, 1982, silkscreen on canvas,
102 × 59$^1/_2$ inches (259.1 × 151.1 cm)
© Estate of Jean-Michel Basquiat. Licensed by Artestar, New York

Amorite refers to the seminomadic people living in Mesopotamia, Palestine, and Syria in the third millenium BCE, founders of Babylon and the ancient city of Mari.

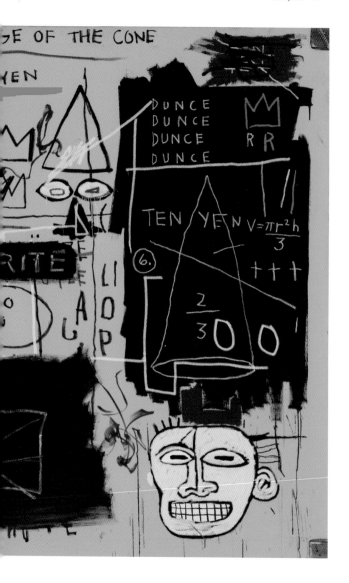

Equals Pi, 1982, acrylic on canvas,
72 x 72 inches (183 x 183 cm)

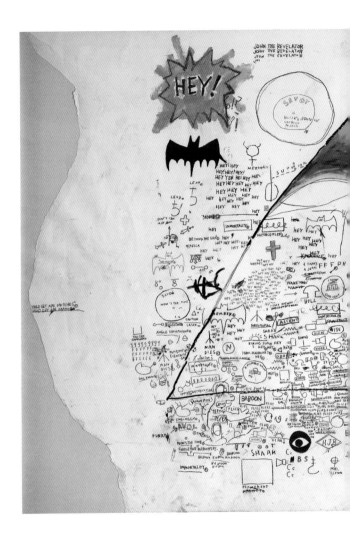

Untitled, 1986, acrylic, collage, and oilstick on paper on canvas,
94 1/8 × 136 1/2 inches (239 × 346.7 cm)
© Estate of Jean-Michel Basquiat. Licensed by Artestar, New York

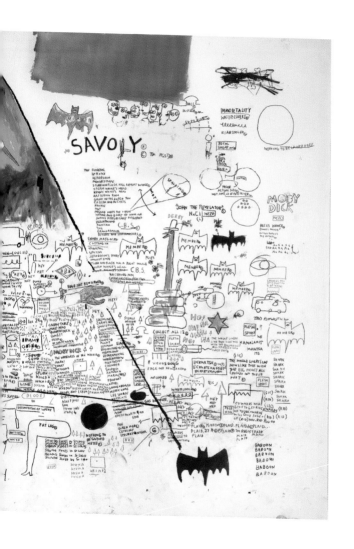

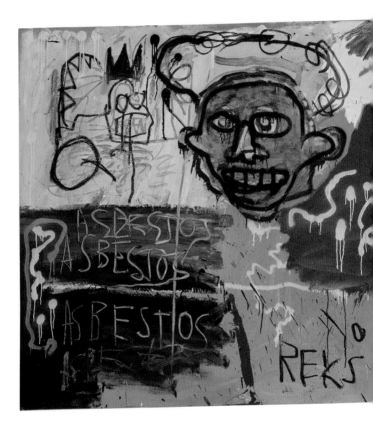

Asbestos refers to the word's literal meaning as a fire repellent, as well as to its identification as a dangerous carcinogen.

Untitled (Pollo Frito), 1982, acrylic, oil, and enamel on two canvases, 60 × 120½ inches (152.4 × 306.1 cm)
© Estate of Jean-Michel Basquiat. Licensed by Artestar, New York

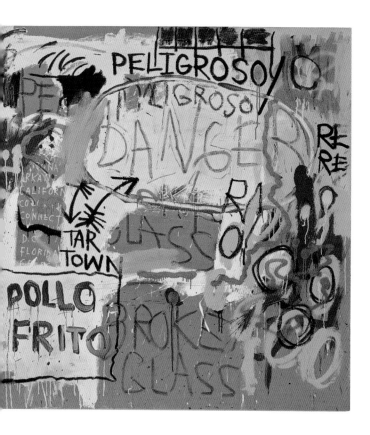

Tar and Tar Town are colloquialisms for Black skin, Black housing settlements, and urban ghettos. Tar is also a petroleum byproduct, and is part of another word grouping that Basquiat sometimes used, which includes Tar, Oil, Petrol, and Gasoline. With those words, Basquiat drew attention to the earth's natural resources, which he felt should be owned by all, but which have become objects of power and wealth at the expense of the majority of people.

Crowns were a signature motif for Basquiat. In *Crowns (Peso Neto)* Basquiat produces an array of crowned and haloed figures as a way to measure the imbalance of power structures, emphasized in the subtitle (Peso Neto is Spanish for "net weight").

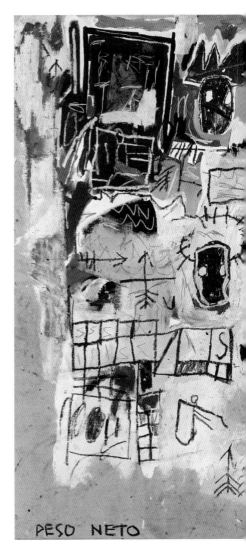

Crowns (Peso Neto), 1981, acrylic, oil paintstick, and collage on canvas, 72 × 94 inches (182.9 × 238.8 cm)
© Estate of Jean-Michel Basquiat. Licensed by Artestar, New York

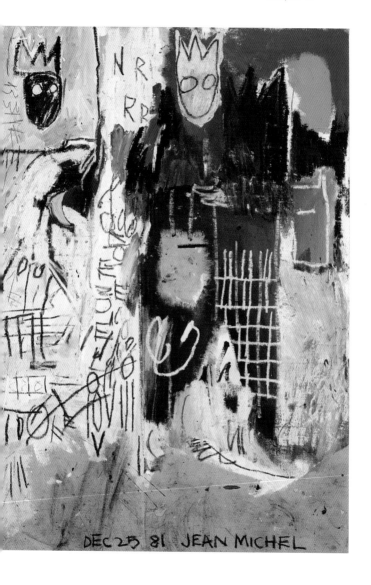

Basquiat melancholic,1983, Crosby Street, New York
Photo: © Roland Hagenberg

MADANNA

BRUCE WALLACE,

WALTER CRONKITE

JARMUSH

GODARD

PEE WEE

NICHOLSON

J. HUSTON

ALI

AMSTROL

JOHN GLENN

MILES DAVIS

KELLE

PRINCE

DAVID LYNCH

WILLIAM BURROWS

ELISABETH TAYLOR

ROBERT DE NIRO

BERNARD GOETZ

RINGO STAR

ELTON JOAN

STEVE WONDER

Untitled notebook page, 1980–1987, mixed media, marker, grease pencil, and ink on ruled paper from a notebook, 9⅝ x 7⅝ inches (24.5 x 19 cm)
© Estate of Jean-Michel Basquiat. Licensed by Artestar, New York

LISTS

Creating lists is one way that Basquiat played with the meaning of words. In his lists, he organized words based on their spelling, definitions, and references to history, literature, and images.

In this untitled work from 1985, Basquiat included famous people of the time. Most are actors, film directors, writers, and musicians, but Basquiat also included a few that are all but unknown today. Some names are crossed out or misspelled, and others appear much darker on the page.

Basquiat used many different criteria in composing his lists, shifting associations as he continued to add names or words. Some of the associations he made between words are still a mystery.

The result is a visual artwork that challenges viewers to read, question, and make sense of what the list of words and numbers means, based on their individual experience and understanding.

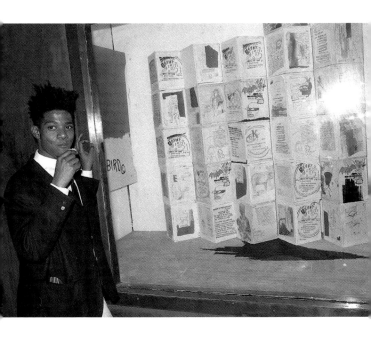

Collage was a defining element of Basquiat's artistic practice, so much so that he eventually invested in a photocopier for his studio. As his career progressed, he began incorporating found materials into his collage works, such as wooden boxes. Basquiat's use of sampling methods such as photocopy, which was unique for his time, has gained him recognition as a pioneer of the pre-digital age.

Jean-Michel Basquiat. Photo: © Ben Buchanan/Bridgeman Images
Artwork: © Estate of Jean-Michel Basquiat. Licensed by Artestar, New York

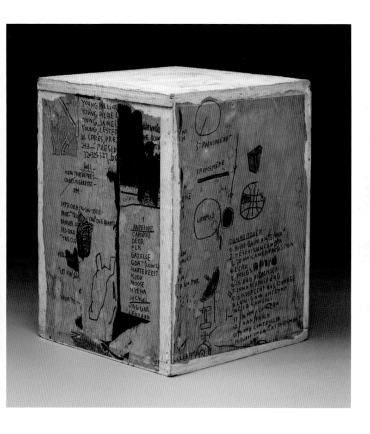

Untitled, 1985, Xerox collage on wood box,
11$^1/_8$ × 8$^1/_2$ × 8$^1/_2$ inches (28.3 × 21.6 × 21.6 cm)

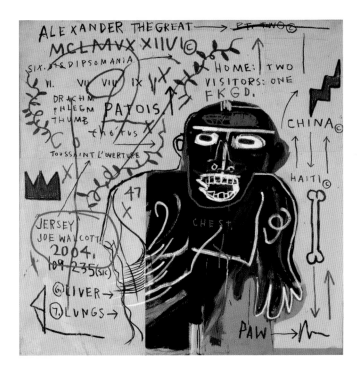

All Coloured Cast III, 1982, acrylic, oilstick and paper collage on canvas,
60 × 60 inches (152.4 × 152.4 cm)
© Estate of Jean-Michel Basquiat. Licensed by Artestar, New York

HISTORY

Basquiat's modern-day world is interwoven with history, including drawn and painted references to African, Aztec, Egyptian, Greek, Roman, and Western European cultures. He also drew upon his African American and Latinx heritages and his identification with past and contemporary Black figures—especially athletes and musicians.

In *All Coloured Cast*, for example, Basquiat lists several referencing Black history, such as the famous boxer Jersey Joe Walcott and Haitian revolutionary Toussaint L'Ouverture, interwoven with mention of Alexander the Great alongside some Roman numerals.

"I was making [a drawing] in an airplane once. I was copying some stuff out of a Roman sculpture book. This lady said, "Oh, what are you studying." I said, "It's a drawing."*

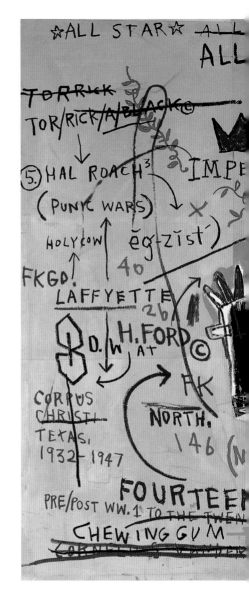

All Colored Cast I, 1982, acrylic, oilstick and paper collage on canvas,
60 × 60 inches (152.4 × 152.4 cm)

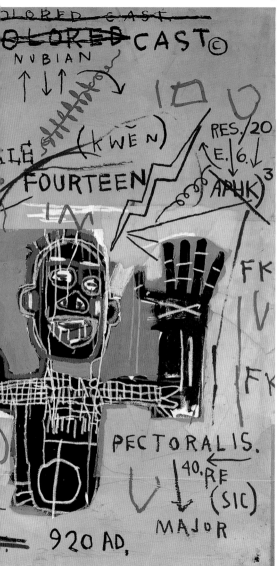

Untitled, 1982, acrylic and oilstick on linen,
76 × 94 inches (193 × 239 cm)

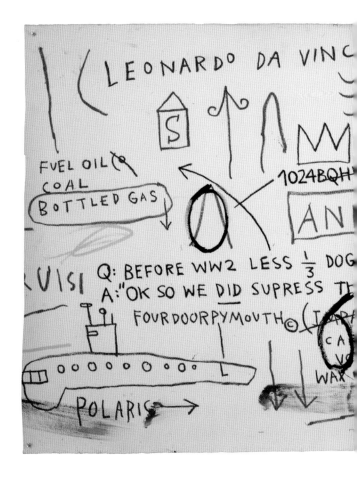

Untitled *(Leonardo da Vinci)*, 1982, acrylic and oilstick on paper,
45 x 77 inches (114.3 × 195.6 cm)
© Estate of Jean-Michel Basquiat. Licensed by Artestar, New York

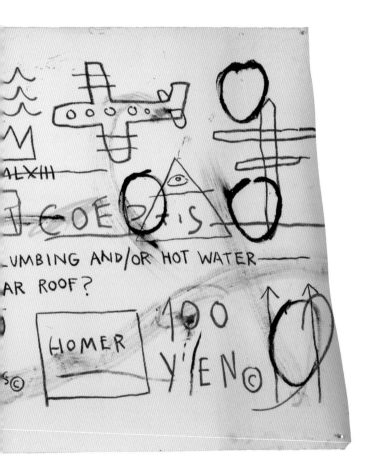

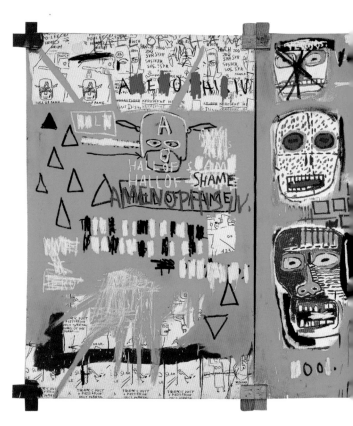

Mitchell Crew, 1983, acrylic, oilstick, and photocopies on canvas
mounted on wood supports with chain,
71^1/$_2$ x 137^3/$_4$ inches (181.6 x 349.9 cm)

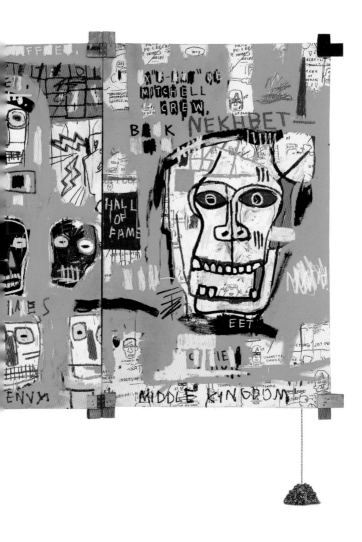

POPULAR CULTURE

Basquiat employed a growing vocabulary of popular images and characters that focus on Black subjects and social inequities. He borrowed these figures from the cartoons and comic books he so admired. He also pulled from the cultural icons found on American television, and thus documented the disturbing presence of anti-Black racism and discrimination in American culture. For instance, look again at *Untitled (Rinso)*.

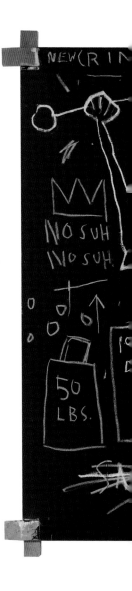

Untitled (Rinso), 1982, acrylic and oilstick on canvas, 72^1/$_2$ x 72^1/$_2$ inches (184.2 x 184.2 cm)
© Estate of Jean-Michel Basquiat. Licensed by Artestar, New York

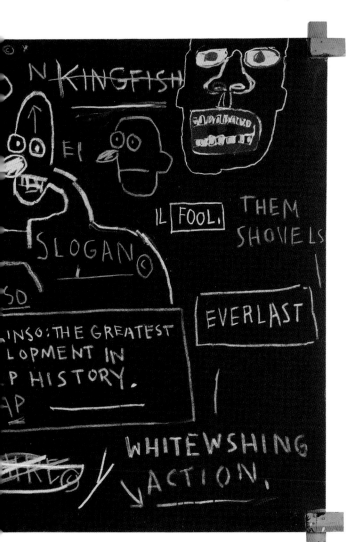

Jean-Michel Basquiat's intimate and at times turbulent friendship with Andy Warhol was one of the most important relationships of his lifetime. The iconic pair first met in 1979 when Basquiat was selling postcards in SoHo with his friend Jennifer Stein. The two spotted Warhol having lunch with art critic Henry Geldzahler, and Basquiat sold him a few postcards, including *Stupid Games*, *Bad Ideas*.

A few years later, Basquiat was properly introduced to Warhol by his dealer, Bruno Bischofberger. Warhol took a Polaroid photograph of Basquiat, who then asked Bischofberger to photograph the two of them together. They invited Basquiat to join them for lunch, but he rushed off, saying he had to return to his studio to work. In less than two hours, Basquiat had one of his studio assistants deliver a painting, still wet, to Warhol. The painting, titled *Dos Cabezas*, depicted the two artists: Warhol on the left wearing his signature wig, his

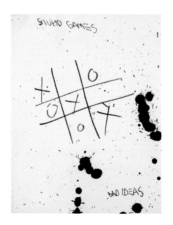

"I just wanted to meet [Andy Warhol]; he was an art hero of mine."*

*Cathleen McGuigan. "New Art, New Money." *New York Times Magazine*, February 10, 1985. https://www.nytimes.com/1985/02/10/magazine/new-art-new-money.html?smid=url-share.

Jean-Michel Basquiat and Jennifer Stein, **Stupid Games, Bad Ideas**, 1979, color photocopy, 5³/₈ x 4³/₈ inches (13.6 x 11 cm)
© Jennifer von Holstein and the Estate of Jean-Michel Basquiat. Licensed by Artestar, New York

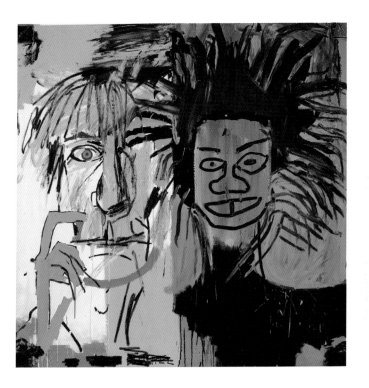

hand resting on his chin, and a contrasting Basquiat on the right, smiling and enthusiastic.

As the friendship between Warhol and Basquiat developed, the two spent time together socially and creatively, collaborating on many projects throughout the 1980s. Basquiat, having always idolized the older

Dos Cabezas, 1982, acrylic and oilstick on canvas, 59³/₄ × 60¹/₂ inches (151.8 × 153.7 cm)
© Estate of Jean-Michel Basquiat. Licensed by Artestar, New York

artist, benefited from his wisdom and art-world cachet, while Warhol was inspired by Basquiat's energy, youth, and innovation. Basquiat's fresh perspective and passion for painting even inspired Warhol to return to painting by hand after a long period of working mainly with silk-screening techniques.

While the two were very close friends, the thirty-two-year age gap caused Warhol to adopt a somewhat paternal role, often by giving the younger artist both personal and professional advice, and encouraging him to adopt healthy habits. Warhol was frequently consulted by Basquiat's friends and peers who worried about him during rough periods in his life. After collaborating on an exhibition that was not well received, Basquiat and Warhol's relationship entered a somewhat turbulent period, with the two barely speaking to each other in their final years. However, Basquiat was deeply affected by Warhol's sudden and unexpected death after complications from a routine surgery, an event often cited as one of the factors that led to Basquiat's own tragic death the following year.

Though short in length, the friendship between Warhol and Basquiat was deeply genuine, playfully symbiotic, and profoundly beneficial on both a personal and artistic level. As Keith Haring observed after a studio visit with the pair: "Each one inspired the other to out-do the next. The collaborations were seemingly

effortless. It was a physical conversation happening in paint instead of words. The sense of humor, the snide remarks, the profound realizations, the simple chit-chat all happened with paint and brushes."[1] To this day, this iconic friendship remains one of the most revolutionary and unprecedented meeting of creative minds.

[1] https://www.sothebys.com/en/articles/tale-of-two-legends-warhol-and-basquiat

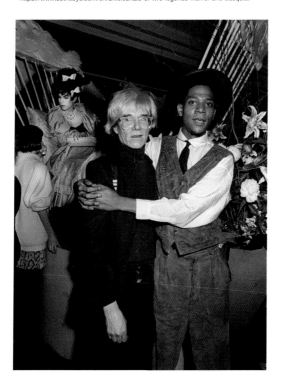

Jean-Michel Basquiat and Andy Warhol at the Area nightclub, New York, 1984
© Ben Buchanan/Bridgeman Images

Hollywood Africans depicts (from
left to right) Toxic, Rammellzee and
Basquiat himself, memorializing a
trip the three artists took together to
Los Angeles. Basquiat's relationship
with Rammellzee included a number
of fruitful collaborations in art,
music, and performance, but was
always competitive and ultimately
contentious. By dubbing his posse
Hollywood Africans, Basquiat drew
a parallel between their outsider
status in the posh and polite LA art
world and the denigrated and limited
token roles historically allowed
Black actors in Hollywood—lowly
stereotypes epitomized by much
of the language in the painting,
including Sugar Cane, Tobacco,
What is Bwana? and Gangsterism.

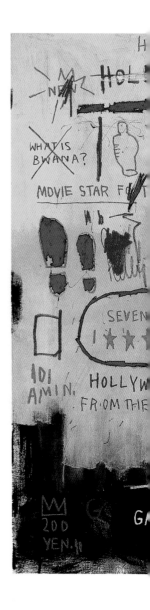

Hollywood Africans, 1983,
acrylic and oil stick on canvas,
84 × 84 inches (213.4 × 213.4 cm)
© Estate of Jean-Michel Basquiat.
Licensed by Artestar, New York

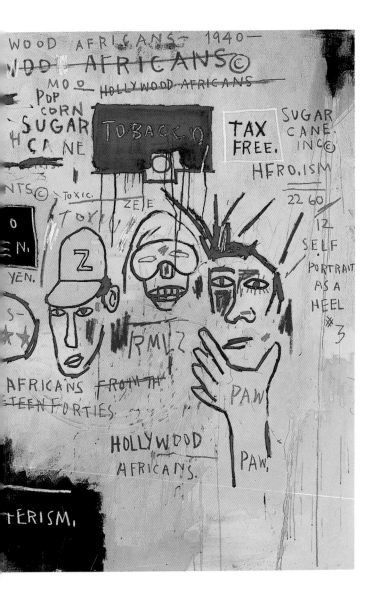

Sugar Cane and **Tobacco** are crops widely harvested by Black labor. "Sugar" is also a slang word for drugs and for white skin color.

A Panel of Experts, 1982,
acrylic and oil paintstick and
paper collage on canvas,
60 × 60 inches
(152.4 × 152.4 cm)
© Estate of Jean-Michel
Basquiat. Licensed by
Artestar, New York

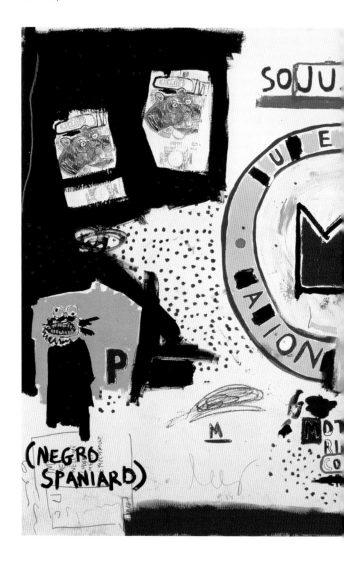

Untitled (*crown*), 1988, acrylic and oil stick on canvas,
40 × 60 inches (101.5 x 152.5 cm)

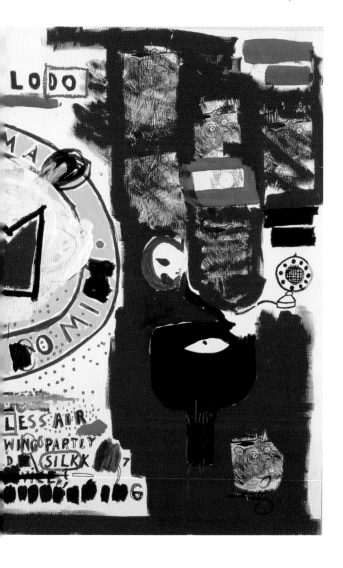

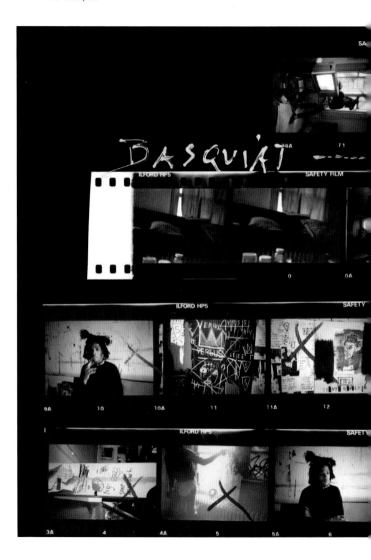

Contact sheet, Crosby Street, New York, 1983
Photo: © Roland Hagenberg
Artwork: © Estate of Jean-Michel Basquiat. Licensed by Artestar, New York

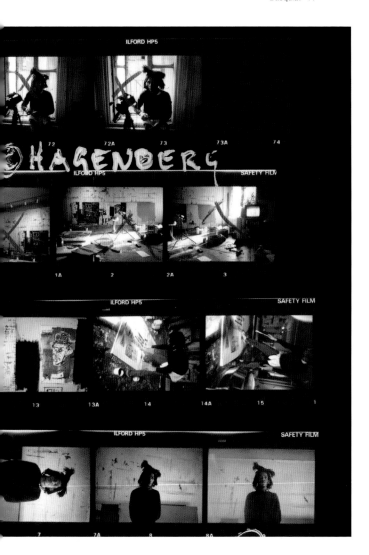

Basquiat's first studio and living space was at 101 Crosby Steet in SoHo. The loft was arranged for him by gallerist Annina Nosei, who was his dealer at the time.

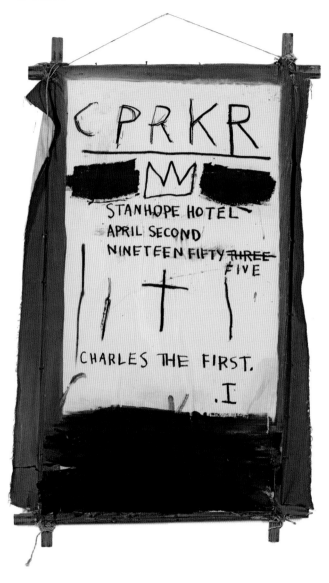

CPRKR, 1982, acrylic, oilstick, and paper collage on canvas, 60 × 40 inches (152.5 × 101.5 cm)

MUSIC

Some say that sound was a significant element in Basquiat's creation of his images. He and his friends were frequently out at night, listening to music and dancing. At the age of nineteen, Basquiat cofounded a band. It was a time when hip-hop culture was coming into its own, a culture that included rap music, fashion, deejaying, break dancing, and graffiti art.

Basquiat also developed a keen interest in jazz music and musicians. Charlie Parker, also known as Bird, was among his favorites. In the 1940s, Parker was a rising star in the jazz revolution that was soon to be named bebop. Through his music, Parker created a new language that expressed the anger of disenfranchised Black Americans.

CPRKR is the first of many paintings that honors Parker and acknowledges his importance not only to the world of music, but to Basquiat himself. The other elements in this painting refer to Parker's death and the memorial service for him. The crown appears below "CPRKR." "Stanhope" refers to the name of the hotel in New York where Parker died; "April Second Nineteen Fifty Three Five" is the month, day, and corrected year of a memorial concert at Carnegie Hall.

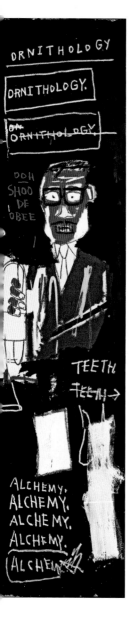

"The Black person is the protagonist in most of my paintings. I realized that I didn't see many paintings with Black people in them."*

*Cathleen McGuigan. "New Art, New Money."
New York Times Magazine, February 10, 1985.

Horn Players, 1983, acrylic and oilstick on three canvases,
96 × 75 inches (243.84 × 190.5 cm)
© Estate of Jean-Michel Basquiat. Licensed by Artestar, New York

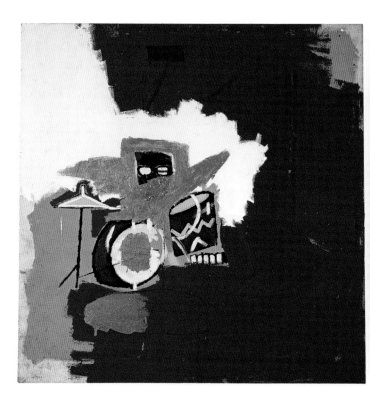

Max Roach, 1984, acrylic and oilstick on canvas,
60 x 60 inches (152.4 x 152.4 cm)

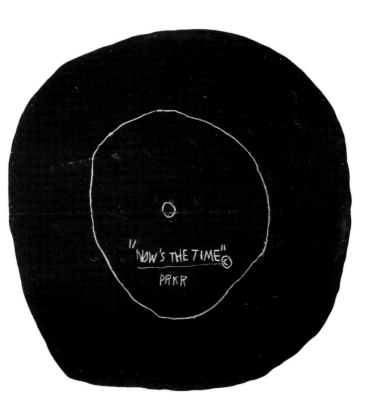

Now's the Time, 1985, acrylic and oilstick on wood,
diameter about 92 1/2 inches (235 cm)

Discography (One), 1983, acrylic and oilstick on canvas,
66 x 60 inches (167.6 x 152.4 cm)
© Estate of Jean-Michel Basquiat. Licensed by Artestar, New York

Discography (Two), 1983, acrylic and oilstick on canvas,
66 x 60 inches (167.6 x 152.4 cm)

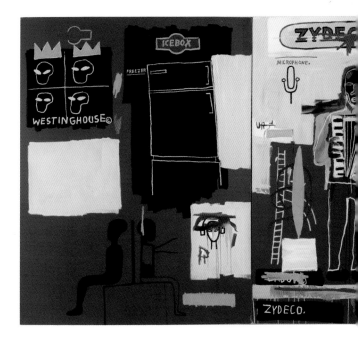

Zydeco, 1984, acrylic and oil stick on canvas, three panels,
86 x 203⁷/₈ inches (218.5 x 518 cm)

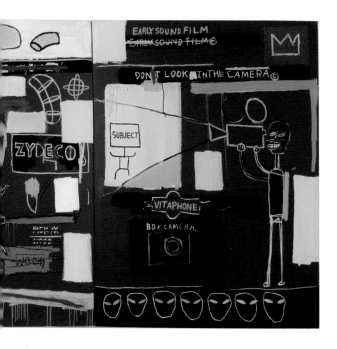

The title and central figure in **Zydeco** reference a genre of American folk music originating from Louisiana Creole culture. On the surface, the painting can be seen as an homage to the Black musicians and musical traditions that Basquiat deeply respected. Crossed out words such as PICK AX and WOOD, however, are suggestive of manual labor and the blighted history of the Black experience in southern America. The cameraman to the right of the musician and the corporate logos WESTINGHOUSE and VITAPHONE add another dimension to the work as well, alluding to the commodification of "Blackness" in the entertainment industry (and art world), and the corporate omnipotence prevalent in American culture.

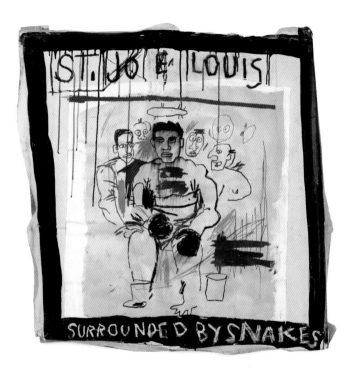

St. Joe Louis Surrounded by Snakes, 1982, acrylic and crayon on canvas,
39¹⁵/₁₆ × 39¹⁵/₁₆ inches (101.5 × 101.5 cm)

SPORTS

Basquiat often depicted images of Black people in response to what he considered a lack of representation of Black men and women in Western art history. Among the figures he commonly referenced were the famous athletes of earlier generations, such as Joe Louis, Jack Johnson, Hank Aaron, Jesse Owens, Muhammad Ali (né Cassius Clay), and Sugar Ray Robinson.

Basquiat conceived the "Famous Negro Athletes" theme early in his career (see next page). Although Basquiat doesn't give us the names of these athletes, he draws a baseball to suggest the sport they play and places the phrase "Famous Negro Athletes" under the baseball. Although he created this artwork in the 1980s, his use of the outdated and racially charged word "Negro" implies that the image may refer to an earlier generation of sports heroes, such as Hank Aaron or Jackie Robinson, and also points to anti-Black racism in the larger culture.

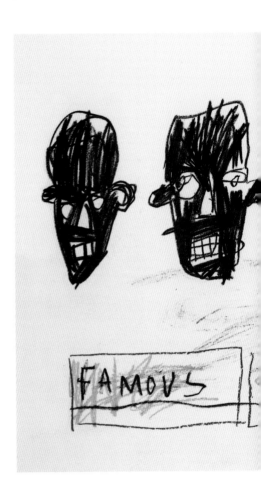

Famous Negro Athletes, 1981, oilstick on paper,
27⁷/₈ x 35 inches (70.8 x 88.9 cm)
© Estate of Jean-Michel Basquiat. Licensed by Artestar, New York

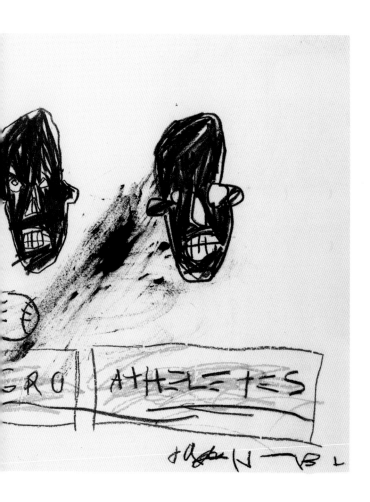

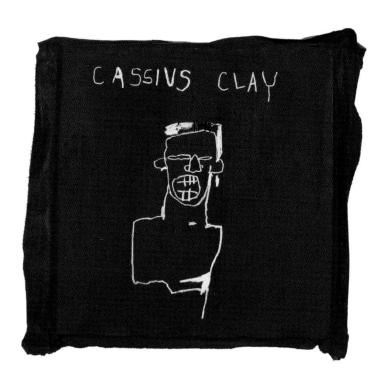

Cassius Clay, 1982, acrylic and oilstick on canvas,
42 x 41 inches (106.7 x 104.1 cm)
© Estate of Jean-Michel Basquiat. Licensed by Artestar, New York

"Since I was seventeen, I thought I might be a star."*

*Dieter Buchhart and Tricia Laughlin Bloom, eds. *Basquiat: The Unknown Notebooks*.
New York: Skira Rizzoli Publications in collaboration with the Brooklyn Museum, 2015, 24.

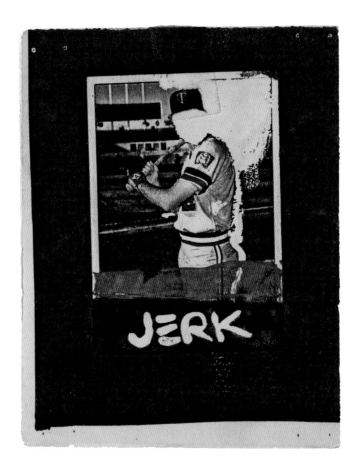

Jean-Michel Basquiat and Jennifer Stein, *Jerk*, 1979, color photocopy,
5³/₈ x 4³/₈ inches (13.6 x 11 cm)

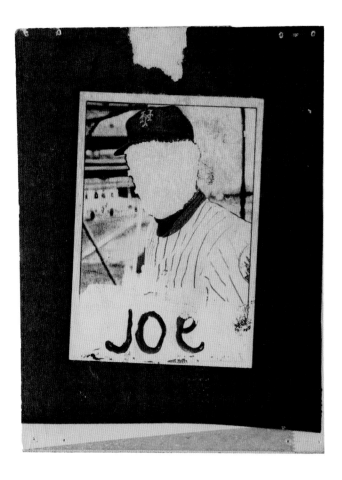

Early in his career, Basquiat produced a series of collaged postcards
that he sold on the streets on New York City. Present in many of
these works are early indications of Basquiat's unique visual language
and tendency to draw from a myriad of cultural references.

Jean-Michel Basquiat and Jennifer Stein, *Joe*, 1979, color photocopy,
$5^5/_8$ x $4^1/_4$ inches (14.4 x 10.8 cm)

Untitled, 1982, acrylic and oilstick on linen,
76¹/₄ x 94 inches (193.5 x 239 cm)
© Estate of Jean-Michel Basquiat. Licensed by Artestar, New York

"Labels don't mean anything."*

*Jean-Michel Basquiat.
Interview by Demosthenes Davvetas. *New Art International,* no. 3, October–November 1988, 10–15.

Andy Warhol, *Jean-Michel Basquiat,* 1985
The Andy Warhol Museum, Pittsburgh;
Contribution The Andy Warhol Foundation for
the Visual Arts, Inc. 2001.2.311

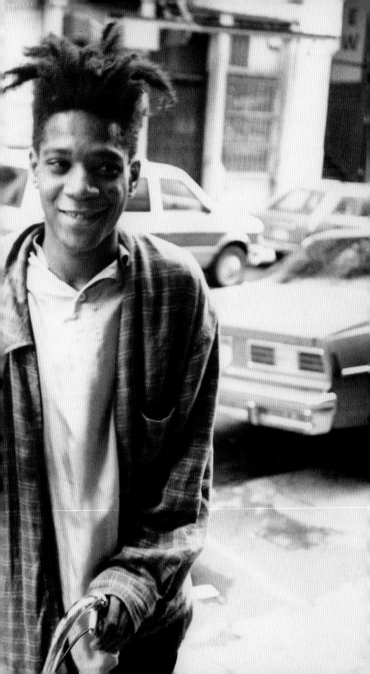

Untitled notebook cover, 1980–1987, mixed media, marker, grease pencil, and ink on cardboard notebook cover, 9⅝ x 7⅝ inches (24.5 x 19 cm)

BASQUIAT'S NOTEBOOKS

Like many artists, Basquiat kept a number of notebooks for drawing and writing. His notebooks were ordinary, inexpensive composition books with ruled pages.

He rarely drew on the back of a page, so that each image or text faces a blank page. The notebooks include everything from drawings of images that appear in his more elaborate paintings, such as crowns and human figures, to everyday information such as lists, names, and telephone numbers. Looking at the notebooks is like taking a peek over Basquiat's shoulder, and they offer an intimate view into his thoughts and his broader artistic practice.

A PRAYER

NICOTINE WALKS ON EGGSHELLS
MEDICATED

THE EARTH WAS FORLE
 FORMLESS VOID
DARKNESS
DARKNESS FACE OF THE DEEP
SPIRIT MOVED ACROSS THE
WATER AND THERE WAS LIGHT

"IT WAS GOOD"©

BREATHING INTO HIS LUNGS
2000 YEARS OF ASBESTOS.

Untitled notebook page, 1980–1987, mixed media, marker, grease pencil,
and ink on ruled paper from a notebook,
9⁵/₈ x 7⁵/₈ inches (24.5 x 19 cm)
© Estate of Jean-Michel Basquiat. Licensed by Artestar, New York

UNTITLED NOTEBOOK PAGE

Basquiat used poetic devices, such as repetition, symbolism, and metaphor to emphasized certain words and ideas in this poem. He included references to the Judeo-Christian creation story, such as the world emerging from darkness and water and light taking form.

He also took the quote "it was good"— a reference to God's satisfaction with his creation— from Genesis, the first book of the Bible. Basquiat juxtaposed these references with dark images to create irony, resulting in meanings that are very different from what the reader expects.

The words "A Prayer" appear in large underlined letters at the top of the page. A prayer is communication with a god or spiritual being that expresses gratitude, need, repentance, or praise.

This page and opposite: ***Untitled notebook pages***, 1980–1987, mixed media, marker, grease pencil, and ink on ruled paper from a notebook, 9⅝ x 7⅝ inches (24.5 x 19 cm)

WORDS = DRAWINGS

Basquiat didn't just draw images—he also drew words. This approach showed the influence of graffiti writing on his practice. Basquiat used words to communicate meaning, but he also emphasized them as visual elements—collections of marks or lines. In drawings and notebook pages, he created his own font, writing in all-capital letters and representing the letter "E" as a stack of three horizontal lines.

RUBBER MONEY AT A BUFFET
CARTS OF SHREDDED WHEAT

LOOT
BOOTY
RANSOM
INFESTED BATHROOMS

HIGHER MONKEYS

SPRING ONIONS

THE HISTORY OF THE WORLD

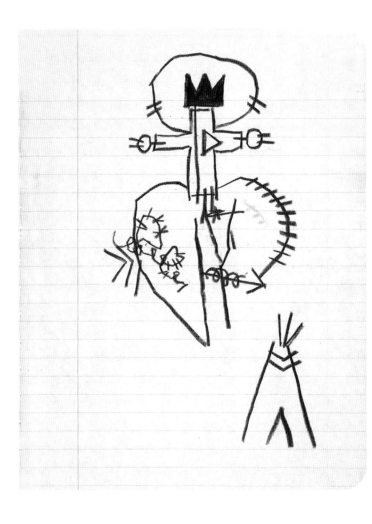

This page and opposite: ***Untitled notebook pages***, 1980–1987, mixed media,
marker, grease pencil, and ink on ruled paper from a notebook,
9⁵/₈ x 7⁵/₈ inches (24.5 x 19 cm)
© Estate of Jean-Michel Basquiat. Licensed by Artestar, New York

SYMBOLS

The notebook pages contain early examples of some of Basquiat's iconic imagery—tepees, crowns, skeleton-like figures, and grimacing faces—that appeared throughout his large-scale paintings. These images became symbols of social injustice, heroes, cultural identity, popular culture, and more.

WAX SEAL
LINE
STAMP

VERY OFFICAL

This page and opposite: *Untitled notebook pages*, 1980–1987, mixed media, marker, grease pencil, and ink on ruled paper from a notebook, 9⅝ x 7⅝ inches (24.5 x 19 cm)

WORDPLAY

Basquiat played with words throughout his note-books, experimenting with their meanings and how those meanings can change. Drawing words and letters, he changed their appearance and challenged the viewer to read them differently. In addition, he created juxtapositions of words to evoke new associations.

"VERY OBVIOUS"
ASKEW
ODD/OFF BASE©

EMPTY AND OBSCURED
THIS TEXT IS AN ORDINARY SORT RESOURCE

BRICK RUINS

TOMB HOLLOW MORTUARIES

VOICES OF AUTHORITY MAKE MAJOR CLAIMS

OTHERS FROM THE EAST

GATHER AROUND THEM

SHO

A BUS TICKET TO SCRATON PENS.

This page and opposite: *Untitled notebook pages*, 1980–1987, mixed media,
marker, grease pencil, and ink on ruled paper from a notebook,
9⅝ x 7⅝ inches (24.5 x 19 cm)
© Estate of Jean-Michel Basquiat. Licensed by Artestar, New York

CROSSED-OUT WORDS

Basquiat crossed out letters and words to challenge the viewer. He once said: "I cross out words so you will see them more; the fact that they are obscured makes you want to read them."*

*Jean-Michel Basquiat, quoted in "Experimental Techniques: Jean-Michel Basquiat—Now's the Time" (A Teacher's Guide), Guggenheim Bilbao.

LOVE IS A LIE

LOVER = LIAR

This page and opposite: *Untitled notebook pages*, 1980–1987, mixed media, marker, grease pencil, and ink on ruled paper from a notebook, $9^5/_8$ x $7^5/_8$ inches (24.5 x 19 cm)

OPEN SPACES

Basquiat usually drew on only one side of a notebook page, leaving the reverse side blank. The open space on the opposite page helps viewers see each drawing as an independent artwork.

Basquiat was thoughtful about where he left open spaces in each drawing as well. He intentionally chose not to draw in certain areas of a page because he understood that open areas can be just as important in an artwork as the marks he made.

CLASS PROGRAM

NAME _472·2073_ ADDRESS_____ _5:00 7:30_

SCHOOL _265 E4M·_ CLASS _2nd._

TIME		PERIOD 1	PERIOD 2	PERIOD 3	PERIOD 4	PERIOD 5	PERIOD 6	PERIOD 7	PERIOD 8
MONDAY	SUBJECT								
	ROOM								
	INSTRUCTOR								
TUESDAY	SUBJECT								
	ROOM			255 1064					
	INSTRUCTOR								
WEDNESDAY	SUBJECT								
	ROOM								
	INSTRUCTOR								
THURSDAY	SUBJECT								
	ROOM								
	INSTRUCTOR								
FRIDAY	SUBJECT								
	ROOM								
	INSTRUCTOR								
SATURDAY	SUBJECT								
	ROOM								
	INSTRUCTOR								

No. 09-4160 • WIDE RULED with MARGIN

60 SHEETS • SIZE 9¾ IN. x 7½ IN.

This page and opposite: **Untitled notebook pages**, 1980–1987, mixed media, marker, grease pencil, and ink on ruled paper from a notebook, $9^{5}/_{8}$ x $7^{5}/_{8}$ inches (24.5 x 19 cm)

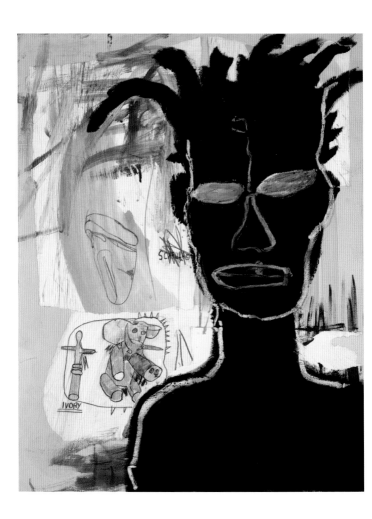

Untitled, 1984, acrylic, oilstick, marker, graphite and xerox collage on canvas,
30 x 24 inches (76 x 61 cm)

REMEMBERING JEAN-MICHEL

Henry Geldzahler

Jean-Michel Basquiat the artist and Jean-Michel Basquiat the poet are one and in perfect harmony. They each exhibit a genius at shorthand and at relationships between objects; lightning-like synapses between feelings and ideas, all transformed by both educated thought and street wisdom. Jean-Michel emerges as a self-educated revealer of tough truth, always in the guise of an entertainer, smiling wryly, even when furious.

Self-educated, a term at times applied to him, is not really an accurate reflection of the ways in which Basquiat arrived at his knowledge and his skills. For the youngster, the Brooklyn Museum, not far from where his family lived, provided an education in the history of art. This great encyclopedic storehouse, among America's finest, stands in stark contrast to the inner-city chaos of neighborhoods only half a dozen blocks away. Both realities were obviously available to the youthful artist. In fact, however, Jean's own background was a great deal more bourgeois than he sometimes liked to let on.

There is no doubt about his preciosity. When I met him in 1980, he was barely twenty. I asked him about which artists he admired: the names Dubuffet, Twombly, Kline, Rauschenberg, and Warhol tripped easily from him, artists whose work and lessons

had been available to him in books and magazines, and at the Museum of Modern Art and the Whitney Museum of American Art.

His mind, for his purposes, worked perfectly. He wasn't after concepts or constructs or the philosophical knowledge of the relationships between ideas. What he lusted after, missed in his education, was factual knowledge: the kind of material the bright ones who don't get thoroughly educated always seem to hunger for.

Thus his preoccupation with lists; he once described his subject matter as "Royalty, Heroism, and the Streets." The lists that are one recurrent feature of his work in both drawing and painting are derived from "copying names out of textbooks and condensed histories" (his words). Anatomy, geography, cartography, dentistry, the Bible, chemistry, alchemy, and the dictionary itself provide him with subjects for his public musings. We are in the presence of both a blackboard in some college course, and the scribbled anger of contemporary urban graffiti. It is a semi-ironical respect for information gathering, a proper evaluation of its weights and pomposities, or rather its absurdities, that animates these works.

Although Basquiat's drawings are in no sense specifically preparatory to the paintings, they do constitute the laboratory in which spontaneity and invention

have freest range. What is true of the drawings applies to the poems—or poetic fragments—that one finds in his early (1980) notebooks. Little stories are told in a telegraphed mode—only to be essentialized still farther a few pages on. Jean's working method seems always to move from the full to the indicated, from the complex to the essence.

There are pages in the notebooks which seem to have been scribbled at some club of the period, loud music hovering; and there are others, the little scenarios, that one guesses are digests of late movies, often played without the sound, as in:

THE MOTORCYCLE PULLS UP TO THE ROAD
DINER MAN GETS OFF
ORDERS A HAMBURGER AND EGG HERO.
"WE PUT UP FAKE CACTUS EVERY YEAR AT THIS
TIME"
A PROUD WORKER COMES OUT OF THE
KITCHEN WITH A
LARGE BAG OF OATS
"THE BUS WILL BE HERE IN 20 MINS./MAKE
SOME HOME FRIES."
THE KITCHEN BOYS WHOOP AND YELL AND
MAKE TWICE AS
MANY DONUTS.
THE MANAGER BRINGS SOME COLOR
POSTCARDS OF ROCKS
FROM UNDERNEATH THE COUNTER BY THE

MINTS AND CIGARS.
THE DISHWASHER PLUGS IN THE JUKEBOX AND
FRIES HIS WET HAND WITH A SHOCK.
THE LAW SITS DOWN FOR FREE SLICE OF PIE.

And, there are fragments that remain long after
reading:

PULL IN A DOG TO DRAW SANDPAPER/CENSOR
HIS HABITS

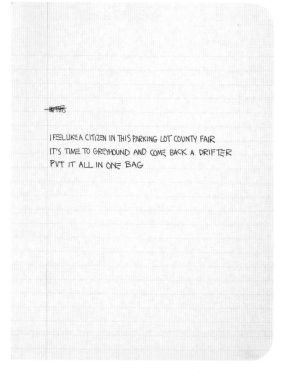

and

LOOT
BOOTY
RANSOM

and

IT'S TIME TO GREYHOUND AND COME BACK A
DRIFTER.

Jean-Michel lived a short life, but he left us with a
lot of memorable work, an astonishing amount given
the number of his working years. The ancient Greeks
believed that lives were not tragically short or satis-
fyingly long; rather, they thought, each life is lived to
its own termination, and should be valued in its own
terms. One might think of him as a warrior who fell
too soon in a battle not of his making.

Henry Geldzahler, introduction to *Jean-Michel Basquiat:*
The Notebooks (New York: Art + Knowledge, 1993).

Henry Geldzahler (1935–1994) was the first curator of twentieth-
century art at the Metropolitan Museum of Art. He became
acquainted with Basquiat in 1980, when the artist was barely twenty,
and remained a close friend as Basquiat's reputation soared.

opposite page: ***Untitled notebook page***, 1980–1987, mixed media,
marker, grease pencil, and ink on ruled paper from a notebook,
$9^5/_8$ x $7^5/_8$ inches (24.5 x 19 cm)
© Estate of Jean-Michel Basquiat. Licensed by Artestar, New York

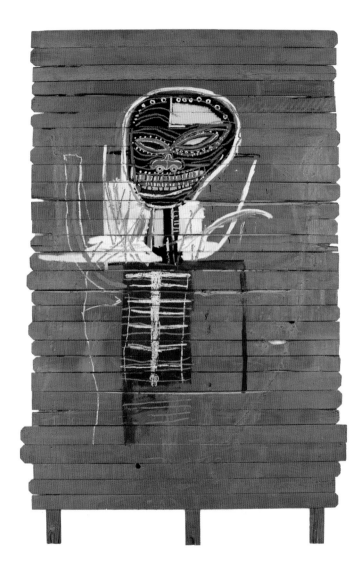

Gold Griot, 1984, acrylic and oilstick on wood,
117 x 73 inches (297.2 x 185.4 cm)
The Broad Art Foundation © Estate of Jean-Michel Basquiat. Licensed by Artestar, New York

HENRY LOUIS GATES JR.

"I feel like a citizen it's time to go and come back a drifter" Jean-Michel Basquiat spray-painted his way into the public consciousness. His tag name was SAMO©, a postmodern pun on "Sambo" and "Satchmo" (to trope on his orthographic style) for the new wave, but the messages he scrawled on the shattered building of the Lower East Side were anything but "the same old shit." They caused even New Yorkers to break and wonder: Who is this pseudonymous, self-copyrighted shaman of the graffiti age?

SAMO© DOES NOT CAUSE CANCER IN
LABORATORY ANIMALS III
SAMO© FOR THE SO-CALLED AVANT-GARDE
SAMO© III AS A CONGLOMERATE OF DORMANT-
GENIUS III
SAMO© III AS AN END TO THE 9-TO-5, WENT 2
COLLEGE, NOT 2NITE
HONEY BLUES

You couldn't be sure what he meant, or where his signature would pop up next, but those in the know knew Jean-Michel Basquiat was going to be one of the freshest artistic voices—and hands—of his or any generation. When he arrived on the scene in the late 1970s, he had an anonymity all but unattainable for an American teen today, in the era of Facebook and Twitter. He also had an ambition to be ranked in the stratosphere of all-time greats, even if he had to box his way into it. The skills, he was still working out—

seemingly at every waking hour, on just about every surface in his grasp—but in his mind the match was set.

Basquiat has slipped his childhood home in Brooklyn for the concrete frontier of the East Village. The fact that it was only a few subway stops away didn't mean it wasn't a different world. Manhattan in the "Ford to City: Drop Dead" years "was a center of cultural ferment—especially in the visual arts," former Talking Heads front man David Byrne has recalled. "New York was legendary. It was where things happened, on the East Coast anyway. One knew in advance that life in New York would not be easy, but there were cheap rents in cold-water lofts without heat, and the excitement of being [there] made up for those hardships."

It was, to quote the title of Patti Smith's award-winning memoir, a time and place for "just kids." And in crossing the East River to join them and the other members of the Downtown 500, Basquiat was traversing the metaphysical boundary between stultification and freedom, alienation and innovation, parental disapproval and dynamic self-creation. It was a ballsy, emancipatory act—a short-but-still-great migration from Kings to New York County—in the African American tradition.

"My free life began on the third of September, 1838," the great Frederick Douglass wrote in the Century

Illustrated Monthly Magazine in November 1881. A century and a half before Basquiat set out for "the center of the cultural ferment," Douglass (né Bailey) penned himself into freedom authoring his slave narrative (which he would revise multiple times) after fleeing his master's house in Maryland for the North's safer shores. Douglass continued:

"On the morning of the fourth of that month, after an anxious and most perilous but safe journey, I found myself in the big city of New York, a FREE MAN— one more added to the mighty throng which, like the confused waves of the troubled sea, surged to and fro between the lofty walls of Broadway. Though dazzled with the wonders which met me on every hand, my thoughts could not be much withdrawn fro my strange situation. For the moment, the dreams of my youth and the hopes of my manhood were completely fulfilled. The bonds that had held me to 'old master' were broken."

Like Douglass, and the hundred other slave memoirists who, miraculously, were able to set their feet on northern ground, and their pens to paper, Basquiat didn't know what awaited him as a free man across the river, but he knew it had to be better than remaining in his overly strict father's house in Boerum Hill. I FEEL A CITIZEN IT'S TIME TO GO AND COME BACK A DRIFTER, Basquiat would write in Notebook 1, composed in 1980–81.

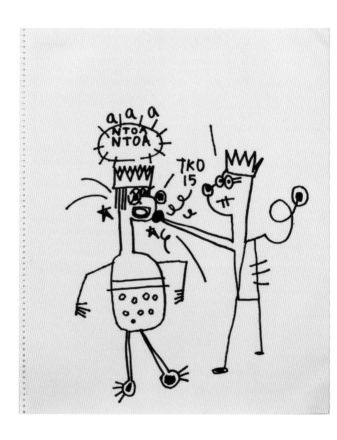

Untitled (Boxer), 1982, Sumi ink on paper,
15⁷/₈ x 13 inches (40.6 x 33 cm)

CHRONOLOGY

1960
December 22: Jean-Michel Basquiat is born at Brooklyn Hospital in Brooklyn, New York. His parents, Gerard Basquiat, born in Port-au-Prince, Haiti, and Matilde Andrades, born in Brooklyn to Puerto Rican parents, live in Brooklyn's Park Slope neighborhood.

1964
Basquiat's sister Lisane is born in Brooklyn.

Basquiat attends kindergarten in the Head Start program. In childhood, he often visits the Brooklyn Museum, the Museum of Modern Art, and the Metropolitan Museum of Art with Matilde, who encourages his interest in art and emphasizes the importance of education.

1967
Basquiat's sister Jeanine is born.

Basquiat attends Saint Ann's, a progressive private school in Brooklyn. He becomes an avid reader in Spanish, French, and English, and a more than competent athlete, competing in track events.

1968
Basquiat makes cartoonlike drawings inspired by cars, comic books, and the films of Alfred Hitchcock.

May 1968: He is hit by an car while playing in the street. He breaks an arm, suffers various internal injuries, and has his spleen removed. While recovering, he receives a copy of *Gray's Anatomy* from his mother. The book makes a lasting impression on him and its influence is seen both in his later work as well as his band Gray, which he cofounds in 1979.

The Basquiats separate and Gerard assumes custody of the three children.

1971

Basquiat leaves Saint Ann's School for PS 181, a public school near the family's new apartment.

1977

Basquiat creates the fictional character SAMO© (pronounced "Same-Oh," referencing the phrase "Same Old Shit"), who makes a living peddling a fake religion. He begins collaborating with Al Diaz on the SAMO© project.

1978

Basquiat leaves home for good; Gerard gives him some money with the understanding that he will try his best to succeed. Basquiat stays with friends, often at the downtown Manhattan loft of British artist and entrepreneur Stan Peskett. There, he becomes friends with musician and graffiti writer Fred Brathwaite (Fab 5 Freddy). Around this time,

he also meets Michael Holman, a future member of the band Gray, and Danny Rosen. He begins frequenting nightclubs. Basquiat, Holman, Rosen, and Vincent Gallo, who would also join Gray, are known as the "baby crowd" in the downtown club scene.

Basquiat sells hand-painted postcards and T-shirts to make money. At a downtown restaurant, he approaches Andy Warhol and the important curator and critic Henry Geldzahler. Basquiat sells a postcard to Warhol, but Geldzahler dismisses him as "too young" to be a serious artist.

Basquiat becomes a regular part of the crowd of filmmakers, musicians, and artists who hang out at the new downtown spots: Club 57, CBGB, Hurrah, Tier 3, and especially the Mudd Club. There, he rubs elbows with musicians David Byrne, Debbie Harry, Madonna, members of the B-52s, John Lurie, and downtown art figures such as Diego Cortez, Edit DeAk, John Sex, and Patti Astor, cofounder of the Fun Gallery.

Through his friendship with Brathwaite, Basquiat becomes familiar with the new hip-hop culture flowering uptown in the streets of Harlem and in the basements of the South Bronx. Deejaying, emceeing, creating graffiti, and break dancing are formative elements of hip-hop. Brathwaite notes that the scene downtown "was pretty much all white except for me, Jean-Michel, and a few other people."

Brathwaite introduces Basquiat to uptown graffitists and rap artists, including Lee Quiñones, Toxic, A-One, and Rammellzee, a graffiti artist and deejay with whom Basquiat soon forms a confrontational but valuable friendship.

1979

Shortly after an article about Basquiat and Diaz is published in the *Village Voice*, their friendship breaks apart, ending the SAMO© collaboration. "SAMO© is dead" begins appearing on walls in downtown Manhattan, especially in the SoHo district.

Basquiat concentrates on painting T-shirts and making postcards, drawings, and collages that combine graffiti art and Abstract Expressionism. He collaborates on many of these works with Jennifer Stein and John Sex. He sells them in Washington Square Park in downtown Manhattan, around SoHo, and in front of the Museum of Modern Art in midtown Manhattan.

While wandering around the School of Visual Arts on East 23rd Street, Basquiat meets fellow artists and downtown scene-makers Keith Haring and Kenny Scharf. He admires the graffiti-like quality of Haring's work and sees him as truly belonging to the graffiti subculture in a way that he, Basquiat, does not. The two are close friends for the rest of their lives.

Through Fred Brathwaite, Basquiat meets Glenn O'Brien, a writer for Andy Warhol's *Interview* magazine and the producer and host of *TV Party*, a program on New York cable television. They become good friends, and Basquiat appears frequently on *TV Party*.

Diego Cortez, an artist and filmmaker, sells some of Basquiat's drawings and eventually shows his work to art dealers. He also formally introduces Basquiat to Henry Geldzahler, who becomes a friend and early collector of Basquiat's work.

1980

June: Basquiat participates in the *Times Square Show*, his first group exhibition. Held in a vacant building in Times Square, the show is organized by Colab (Collaborative Projects Incorporated), an artist-run organization based on the Lower East Side, and Fashion Moda, a graffiti-based alternative gallery space in the South Bronx.

The more than one hundred artists in the show include David Hammons, Jenny Holzer, John Ahearn, Jane Dickson, Joe Lewis, Lee Quiñones, Kenny Scharf, and Kiki Smith. The *Times Square Show* is enthusiastically received, becoming an early step in legitimizing the artists of the East Village club scene and marking the beginning of a warm but short-lived reception for the graffitists in the New York art world.

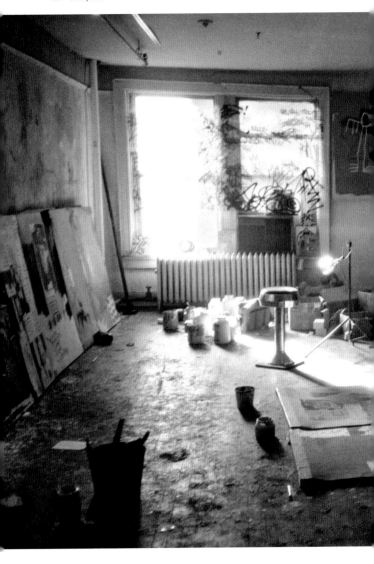

Basquiat's studio, 1983, Crosby Street, New York
Photo: © Roland Hagenberg

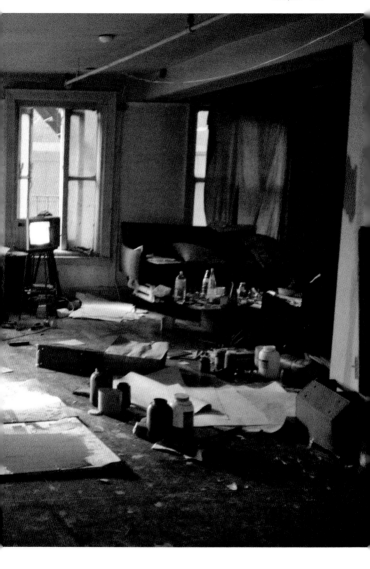

Autumn: Basquiat is chosen to play the lead role in the film *New York Beat*, written by Glenn O'Brien and directed by Edo Bertoglio. Focusing on the downtown art scene and inspired by Basquiat himself, the film begins shooting in December. Later retitled *Downtown 81*, the film is released in 2000.

1981
February: Basquiat is included in *New York / New Wave*, a group exhibition organized by Diego Cortez for the Institute for Art and Urban Resources (now PS1), in Long Island City, Queens. The show presents more than seventy artists, including Keith Haring, Robert Mapplethorpe, Kenny Scharf, Donald Joseph White (a.k.a. Dondi), Futura 2000, Nan Goldin, Fred Brathwaite, and Andy Warhol. Basquiat's work attracts the attention of dealers Emilio Mazzoli, Bruno Bischofberger, and Annina Nosei.

February 22–March 15: Basquiat's *Flats Fix* (1981) is included in the *Lower Manhattan Drawing Show*, an exhibition organized by Keith Haring at the downtown space the Mudd Club.

April: Brathwaite and graffiti artist Futura organize *Beyond Words: Graffiti Based-Rooted-Inspired Work*s at the Mudd Club. The show includes work by Basquiat (as SAMO©), Keith Haring, Tseng Kwong Chi, Daze, Phase 2, Iggy Pop, Kenny Scharf, and Rammellzee.

May: Basquiat travels to Europe for the first time, for his first solo exhibition at Galleria d'Arte Emilio Mazzoli in Modena, Italy.

September: Annina Nosei invites Basquiat to use her gallery's basement as a studio.

October: He participates in *Public Address*, a group show at Annina Nosei Gallery in New York. The exhibition focuses on sociopolitical themes, with works by Keith Haring, Jenny Holzer, and Barbara Kruger.

December: The first extensive article on Basquiat, "The Radiant Child," by René Ricard, appears in *Artforum*.

1982

March: Basquiat's first solo exhibition in the United States is held at Annina Nosei Gallery. Paintings shown include *Arroz con Pollo*, *Self-Portrait*, *Crowns (Peso Neto)*, and *Untitled (Per Capita)*.

April: He travels to Los Angeles for a solo show at the Gagosian Gallery. Paintings shown include *Six Crimes*, *Untitled (LA Painting)*, and *Untitled (Yellow Tar and Feathers)*.

September: His first solo exhibition at Galerie Bruno Bischofberger opens in Zürich. Works shown include *Man from Naples*, *Crown Hotel*, and *Multiflavors*.

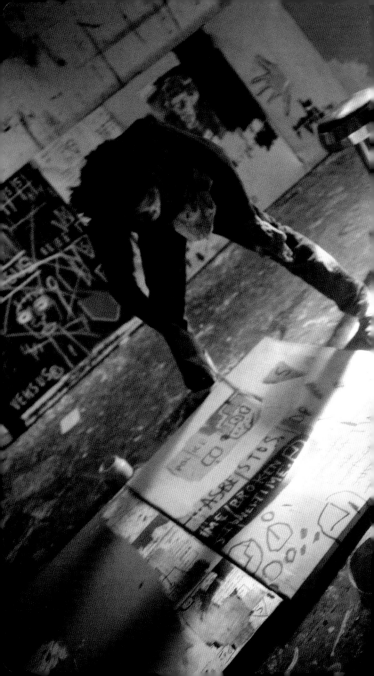

Roland Hagenberg, an Austrian photographer, writer, and publisher, moved to New York City in the early 1980s. There, he captured many of the most important artists working in downtown Manhattan at the time, producing insightful and of-the-moment guidebooks on the burgeoning art scenes in Soho and the East Village. His many photographs of the already renowned Jean-Michel Basquiat working in his Crosby Street Studio are of singular importance today as unique documents of the artist's process. In his photographs we are privy to the dynamic way in which Basquiat approached painting—a kind of freeform action painting and expressionist choreography that echoes Hans Namuth's legendary pictures of Jackson Pollock thirty years before.

Basquiat painting with bar stool, Crosby Street, New York, 1983
Photo: © Roland Hagenberg
Artwork: © Estate of Jean-Michel Basquiat. Licensed by Artestar, New York

November: A solo exhibition is held at Fun Gallery on the Lower East Side. Designed by Basquiat, the crowded, so-called messy installation may have been his response to criticism that, with rising international fame and shows in more established SoHo galleries, his work had lost some of its originality. Paintings shown include *Cabeza*, *Charles the First*, *Jawbone of an Ass*, *Three Quarters of Olympia Minus the Servant*, and *Untitled (Sugar Ray Robinson)*. These works were among his favorites, and he kept them for his personal collection.

1983

March: Basquiat returns to Los Angeles for a second solo show at Gagosian Gallery. Paintings shown include *Jack Johnson*, *Eyes and Eggs*, *Hollywood Africans*, *All Colored Cast (Parts I and II)*, and other works featuring images and text related to famous boxers, musicians, and Hollywood films and the roles that Black people played in them.

Rammellzee and Toxic join him in Los Angeles before the show. *Hollywood Africans*—now in the collection of the Whitney Museum of American Art—is a portrait of the three friends, their heads floating in a triumvirate over a yellow background.

At age twenty-two, Basquiat becomes one of the youngest artists ever included in a Whitney Biennial. The exhibition features his paintings *Dutch Settlers*

and *Untitled (Skull)* as well as work by more than forty other artists, including Keith Haring, Barbara Kruger, David Salle, and Cindy Sherman.

1984

January: Basquiat makes his first visit to Maui, Hawaii. He rents a house in the town of Hana, on a remote part of the island, where he sets up a studio to make drawings and paintings with materials sent from Los Angeles.

Mary Boone and Bruno Bischofberger become Basquiat's primary dealers, jointly organizing exhibitions.

February: Bischofberger suggests the idea of collaborating with Basquiat to Andy Warhol and Francesco Clemente. Both accept and soon start working with him.

May: Basquiat's first solo exhibition at Mary Boone Gallery in New York is a resounding success. Paintings shown include *Bird as Buddha*, *Brown Spots*, *Eye*, *Untitled (Africa)*, and *Wine of Babylon*.

August: His first museum exhibition opens at the Fruitmarket Gallery in Edinburgh, organized by Mark Francis. Surveying paintings from 1981 to 1984, the exhibition travels to the Institute for Contemporary Arts in London, and Boymans van Beuningen Museum in Rotterdam, the Netherlands, on a tour that extends into 1985.

September: *Collaborations—Basquiat, Clemente, Warhol*, a group of fifteen paintings, opens at Galerie Bruno Bischofberger in Zürich.

1985
January: Basquiat's solo exhibition opens at Galerie Bruno Bischofberger in Zürich. Paintings shown include *Max Roach*, *P-Z*, *Tabac*, and *Zydeco*.

February: He appears on the cover of the *New York Times* magazine, posing barefoot for Cathleen McGuigan's extensive article "New Art, New Money: The Marketing of an American Artist."

March: His second solo show opens at Mary Boone Gallery in New York. The catalog includes an essay by eminent scholar Robert Farris Thompson, who situates Basquiat's art in the Afro-Atlantic tradition—a context in which it had never before been discussed. Paintings shown include *Gold Griot*, *Grillo*, *Flexible*, *Wicker*, and *His Glue-Sniffing Valet*.

September: Sixteen collaborative paintings by Basquiat and Warhol are shown at Tony Shafrazi Gallery in New York. At Shafrazi's suggestion, the two artists pose together in boxing trunks and gloves for a poster advertising the show.

1986
August: Basquiat travels to Africa for the first time,

accompanied by his girlfriend, Jennifer Goode, and her brother, Eric. He is joined there by Bruno Bischofberger, who, at Basquiat's urging, arranges for a show in Abidjan, Côte d'Ivoire. Paintings shown include *Charles the First* and *Jawbone of an Ass*.

November: A large survey exhibition of more than sixty paintings and drawings, organized by Carl Haenlein, opens at the Kestner Gesellschaft in Hannover, Germany. At age twenty-five, Basquiat is the youngest artist ever to be given an exhibition the institution.

1987
February 22: Andy Warhol dies, at age fifty-eight, after gallbladder surgery. Although their friendship had suffered in the previous year as their work had moved in different directions, Basquiat is devastated. He paints *Gravestone* in memoriam. He becomes more reclusive, often refusing to see friends.

1988
January: Vrej Baghoomian arranges for an exhibition of Basquiat's new paintings for just one night in the Cable Building in SoHo before they are sent to shows in Paris and Düsseldorf, Germany.

Basquiat travels to Paris for the solo show at Galerie Yvon Lambert. Paintings shown include *Light Blue Movers*, *Riddle Me This Batman*, and *She Installs*

Confidence and Picks His Brain Like a Salad. Later in January, he travels to Düsseldorf, Germany, for a solo exhibition at the Galerie Hans Mayer.

June: He spends time in Maui and returns to New York at the end of the month, having stopped for a week in Los Angeles.

August 12: Jean-Michel Basquiat dies in his downtown Manhattan loft at age twenty-seven.

August 17: A private funeral is held at Frank E. Campbell Funeral Chapel, near the Metropolitan Museum of Art uptown. The funeral is attended by immediate family and close friends, including Keith Haring, Francesco Clemente, and Paige Powell. Jeffrey Deitch delivers the eulogy. Basquiat is buried at Green-Wood Cemetery in Brooklyn.

1990
February 16: Keith Haring dies of AIDS-related complications at age thirty-one.

November: Robert Miller Gallery in New York and the Estate of Jean-Michel Basquiat present a survey of Basquiat's drawings, with an accompanying catalog.

December 15: A memorial exhibition of Keith Haring's and Basquiat's work opens at Tony Shafrazi Gallery in New York.

A MEMORIAL GATHERING FOR

JEAN-MICHEL BASQUIAT

(1960–1988)

SATURDAY 5 NOVEMBER 1988
AT 2:30 PM
ST. PETER'S CHURCH
619 LEXINGTON AVENUE
AT 54 STREET

November 5, 1988: Some three hundred friends and admirers attend a memorial gathering at Saint Peter's Church in midtown Manhattan. Music is played by surviving members of Gray and others; Fred Brathwaite recites Langston Hughes's poem "Genius Child" (1937), and Suzanne Mallouk delivers a particularly moving reading of A. R. Penck's "Poem for Basquiat" (1984).

1992

October: The Whitney Museum of American Art presents the artist's first major museum retrospective, *Jean-Michel Basquiat*, curated by Richard Marshall.

1994

Exhibitions of Basquiat's works are held at Henry Art Gallery in Seattle; Galerie Delta in Rotterdam, the Netherlands; and Robert Miller Gallery in New York. Another exhibition, *Jean-Michel Basquiat: The Blue Ribbon Series*, travels from Mount Holyoke College Art Museum in Massachusetts to the Wadsworth Atheneum in Connecticut; the Andy Warhol Museum in Pittsburgh; and the Neuberger Museum of Art in Purchase, New York. The show continues touring into 1996.

1996

Solo exhibitions of Basquiat's works are held at the Serpentine Gallery in London, and Palacio Episcopal de Málaga in Spain. Enrico Navarra publishes a two-volume book on Basquiat's paintings.

August: The film *Basquiat*, directed by Julian Schnabel and featuring Jeffrey Wright, David Bowie, Dennis Hopper, Claire Forlani, and Gary Oldman, is released by Miramax Films.

1997

Basquiat's works are presented at the Kaohsiung Museum of Fine Arts in Kaohsiung; Taichung

Museum; Fondation Dina Vierny-Musée Maillol in Paris; Gallery Hyundai in Seoul; Mitsukoshi Museum in Tokyo; and Museo Nacional de Bellas Artes in Buenos Aires.

1998
Solo exhibitions of Basquiat's works are held at the Museu de Arte Moderna in Recife, Brazil, and the Pinacoteca in São Paulo, Brazil.

1999
February–May: A large exhibition of Basquiat's art is held at the KunstHausWien in Vienna, Austria, accompanied by a catalog.

June: The survey exhibition *Basquiat a Venezia* opens at Fondazione Bevilacqua La Masa as part of the 48th Venice Biennale.

October: The exhibition *Jean-Michel Basquiat: Selected Paintings and Drawings* opens at Tony Shafrazi Gallery in New York.

2000
November: The exhibition *Basquiat en La Habana* is presented as part of the seventh Biennial de La Habana, accompanied by a catalog.

2002
Exhibitions of Basquiat's works are shown at Gagosian

Gallery in Beverly Hills (collaborative paintings with Warhol), and Galerie Sho in Tokyo. Presented at Spike Gallery in New York, *Jean-Michel Basquiat: War Paint* is accompanied by a catalog with an essay by curator and art historian Libby Lumpkin.

2004
Basquiat's works are included in the exhibition *Latin American and Caribbean Art: MoMA at El Museo*, organized jointly by the Museum of Modern Art and El Museo del Barrio in New York.

2005
March: The Brooklyn Museum—where Basquiat spent formative years looking at art—opens an exhibition of more than one hundred paintings and drawings. This major retrospective travels to the Museum of Contemporary Art in Los Angeles and the Museum of Fine Arts in Houston, Texas, through February 2006.

2006
May: *Jean-Michel Basquiat: 1981, The Studio of the Street*, curated by Diego Cortez and Glenn O'Brien, opens at Projects in New York, accompanied by a catalog.

2008
December: Basquiat's works are included in *30 Americans*, an exhibition of African American artists at the Rubell Family Collection in Miami.

2009

December: The film *Jean-Michel Basquiat: The Radiant Child*, directed by Tamra Davis and produced by Arthouse Films, is previewed at Art Basel in Miami Beach.

2010

January: The final cut of *Jean-Michel Basquiat: The Radiant Child* premieres at the Sundance Film Festival.

May: A major retrospective curated by Dieter Buchhart and Sam Keller opens at the Fondation Beyeler in Basel, in the year Basquiat would have turned fifty. In October, the exhibition travels to the Musée d'Art Moderne de la Ville de Paris.

2012–2014

Basquiat's work is included in many major museum and traveling group exhibitions, including *Blues for Smoke* at the Museum of Contemporary Art in Los Angeles, which later travels to the Whitney Museum of American Art and then to the Wexner Center for the Arts in Columbus, Ohio; and *Caribbean: Crosswords of the World*, held in New York at El Museo del Barrio, the Queens Museum, and the Studio Museum in Harlem.

2013

February–April: A retrospective of Basquiat's work is presented at the Gagosian Gallery in New York.

May–June: Sotheby's New York presents *Man Made: Jean-Michel Basquiat*, an exhibition and sale of more than thirty of Basquiat's works, most of which had rarely or never been shown in public.

May–August: The Gagosian Gallery in Hong Kong shows a small exhibition of Basquiat's work, uncharacteristically shifting the focus to his later works.

2014

May–June: *Jean-Michel Basquiat Drawing: Works from the Schorr Family Collection* is held at Acquavella Galleries in New York, featuring works from the collection of Herbert and Lenore Schorr, friends of Basquiat's who had begun collecting his art in 1981.

October: *Basquiat and the Bayou* opens at the Ogden Museum of Southern Art in New Orleans.

2015

April: *Basquiat: The Unknown Notebooks* opens at the Brooklyn Museum. Never before exhibited in full, Basquiat's notebooks provide unique insights into the artist's creative process and the importance of language and the written word in his aesthetic. A facsimile of the notebooks is published by Princeton University Press.

February: *Jean-Michel Basquiat: Now's the Time* opens at the Art Gallery of Ontario in Toronto and travels to the Guggenheim Bilbao.

2016

May: *Words Are All We Have: Paintings by Jean-Michel Basquiat* opens at Nahmad Contemporary in New York.

2016–2017

Basquiat: The Unknown Notebooks travels to the High Museum of Art in Atlanta, Georgia; the Pérez Art Museum in Miami; and the Cleveland Museum of Art.

2017

February: *Basquiat before Basquiat: East 12th Street, 1979–1980* opens at the Museum of Contemporary Art in Denver, Colorado, and travels to the Cranbrook Art Museum in Bloomfield Hills, Michigan.

May: Basquiat's *Untitled* (1982) sells for a record $110.5 million at Sotheby's, becoming the sixth most expensive work ever sold at auction.

September: *Basquiat: Boom for Real* opens at the Barbican Art Gallery in London and travels to the Schirn Kunsthalle in Frankfurt am Main, Germany.

2018

January: *One Basquiat*, the first museum presentation of *Untitled* (1982), opens at the Brooklyn Museum.

October: *Jean-Michel Basquiat—Egon Schiele* opens at the Fondation Louis Vuitton in Paris. A French

translation of *The Notebooks* is published by Princeton University Press in conjunction with the show.

2019
Major exhibitions of Basquiat's work open at the Brandt Foundation, New York; the National Gallery of Victoria, Melbourne; the Guggenheim Museum, New York; and the Mori Art Museum, Tokyo.

2020–2021
October–July: *Writing the Future: Basquiat and the Hip-Hop Generation* opens at the Museum of Fine Arts, Boston.

2022–2023
April: *King Pleasure*, an exhibition of over 200 never-before-seen and rarely shown works, opens in New York.

September–January: *Jean-Michel Basquiat: Symbols* runs at The Albertina Modern, Vienna, Austria.

September–January: *Somewhere Downtown,* UCCA Center for Contemporary Art, Beijing, China.

October–February: *Seeing Loud: Basquiat and Music* is presented at the Montreal Museum of Fine Arts, Montreal, Canada.

This chronology is primarily excerpted from a chronology by Franklin Sirmans, among other sources.

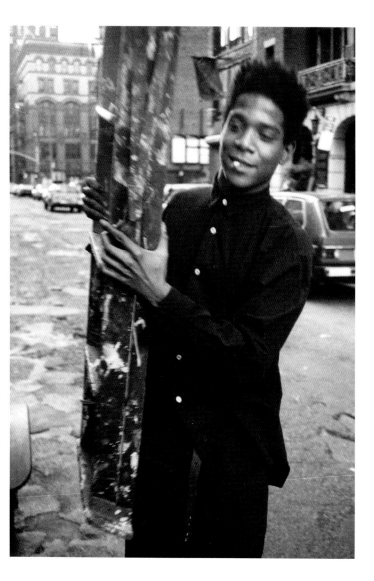

Andy Warhol, *Jean-Michel Basquiat*, 1984
The Andy Warhol Museum, Pittsburgh; Founding Collection,
Contribution The Andy Warhol Foundation for the Visual Arts, Inc. 1998.1.3087

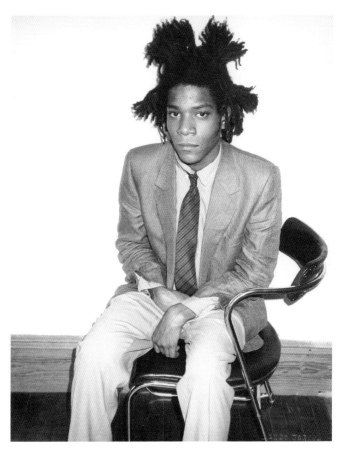

Andy Warhol, *Jean-Michel Basquiat,* 1982, The Andy Warhol Museum, Pittsburgh;
Contribution The Andy Warhol Foundation for the Visual Arts, Inc. 2001.2.549

ACKNOWLEDGMENTS

This book is a result of the hard work and dedication of many amazing individuals.

I cannot overstate my gratitude for the continued support and encouragement of Jeanine Heriveaux and Lisane Basquiat, Nora Fitzpatrick, and the entire Basquiat family throughout the years. Their work expands upon the incredible energy of Gerard Basquiat and his tireless promotion of Jean-Michel's legacy during his lifetime. His spirit and force have been an inspiration to me and many others. It remains an honor and a privilege to be aligned with this incredible family and legacy.

Thank you to David Stark, Sara Citarella, Natalie Bryt, Alex de Ronde, Ted Beckstead, Mary McGing, Ari Gamshad, Christina Burns, and the entire teams at Artestar and Rome Pays Off for their crucial contributions to this publication and their accomplishments in bringing Jean-Michel's work to a worldwide audience.

My sincere thanks to Henry Louis Gates Jr. for the addition of his insightful essay and his long years of friendship.

My thanks as well to the late Henry Geldzahler, who exposed me early on to Jean-Michel's work.

The late René Ricard was also crucial in shaping my journey with Jean-Michel's work.

My deepest thanks in memoriam to Lawrence Weiner, an extraordinary artist, voice, friend, and collaborator. It was an honor to work with him. His impact will be everlasting.

Additional thanks go to a celebrated group of friends, colleagues, and supporters of Jean-Michel, including (but not limited to): Patti Astor, Cordell Broadus, Dieter Buchhart, Rich Colicchio, Mike Dean, Jeffrey Deitch, Carlos "Oggizery Los" Desrosiers, Louise Donegan, Brian Donnelly, Ferg, Futura, Janet and Jonathan Geldzahler, Julia Gruen, Steven Lack, Carlo McCormick, Randall "Sickamore" Medford, Keith Miller, Mary-Ann Monforton, Hiroko Onoda, Oliver Sanchez, Travis Scott, Tony Shafrazi, Franklin Sirmans, Bill Stelling, and Gil Vasquez.

I humbly honor those in memoriam: Virgil Abloh, Allan Arnold, Bobby Breslau, Arch Connelly, Dan Friedman, Richard Hamilton, Keith Haring, Kiely Jenkins, Adolfo Sanchez, Michael Stewart, Tseng Kwong Chi, David Wwojnarowicz, and O.W.

Special thanks to Susan Delson, Hannah Alderfer, Fiona Graham, Karen Lautanen, and Rickey Kim for their invaluable research, design, organization, and editorial support of this publication. Thanks to as well to Taliesin Thomas and Steven Rodríguez for their continued support.

My sincere thanks as well to Kevin Wong, Man Huang, Hassan Ali Khan, Keith Estiler, Keith Miller, John Cahill, John Pelosi, Angelo DiStefano, and Haisong Li for their global support.

Finally, I give all my thanks to my amazing wife, Abbey, and my wonderful children, Justin, Ethan, Ellie, and Jonah for their love and encouragement.

And as always, my love and thanks to my mother Judith.

Larry Warsh
New York City
September 2023

LARRY WARSH

LARRY WARSH has been active in the art world for more than thirty years as a publisher and artist-collaborator. An early collector of Keith Haring and Jean-Michel Basquiat, Warsh was a lead organizer for the exhibition *Basquiat: The Unknown Notebooks*, which debuted at the Brooklyn Museum, New York, in 2015, and later traveled to several American museums. He also served as a curatorial consultant on *Keith Haring/Jean-Michel Basquiat: Crossing Lines* for the National Gallery of Victoria. The founder of Museums Magazine, Warsh has been involved in many publishing projects and is the editor of several other titles published by Princeton University Press, including *Basquiat-isms* (2019), *Haring-isms* (2020), *Futura-isms* (2021), *Abloh-isms* (2021), *Arsham-isms* (2021), *Warhol-isms* (2022), *Hirst-isms* (2022), *Pharrell-isms* (2023), *Judy Chicago-isms* (2023), *Holzer-isms* (2024), *Neshat-isms* (2024), *Jean-Michel Basquiat's The Notebooks* (2017), and *Keith Haring: 31 Subway Drawings* (2012), among others. Warsh has served on the board of the Getty Museum Photographs Council, and was a founding member of the Basquiat Authentication Committee until its dissolution in 2012.

NO MORE RULERS

NO MORE RULERS (NMR) is on a mission to rethink the way we define art and creative expression. Based in New York, NMR is a publishing company dedicated to empowering the creative community and questioning the status quo. Our artist publications erase the boundaries between high and low, popular culture and fine art, and between traditional categories like design, music, and fashion. By partnering with global institutions and focusing on topics ranging from contemporary culture to artistic process to creativity, we're creating a world where art can truly be for everyone.

NO MORE RULERS